ETSY

A Comprehensive Guide on How to
Start an Etsy Business and Market Your
Etsy Store Using Social Media

Christopher Kent

Table of Contents

By reading this document, the reader agrees that under no circumstances is the author responsible for any losses, direct or indirect, which are incurred as a result of the use of information contained within this document, including, but not limited to, — errors, omissions, or inaccuracies.

ETSY

Step-by-Step Guide on How to Start an Etsy Business for Beginners

By Christopher Kent

INTRODUCTION

I want to thank you for choosing this book, *'Etsy - Step-by-Step Guide on How to Start an Etsy Business for Beginners.'*

You can turn your hobby or love for craft into a thriving business by using Etsy. Most of the sellers on Etsy are quite confident about their artistic and crafting skills. However, many still need guidance about all the different aspects of starting, running and maintaining a successful business on Etsy. So, if you are interested in starting your own business on Etsy and aren't sure where to begin, then this is the perfect book for you.

In this book, you will learn what Etsy is about, the different benefits of using this platform, steps to creating a successful Etsy store, tips for marketing and maintaining a profitable business and everything else that you need to know to start your business on Etsy. This book is a step-by-step guide that provides information about different aspects of Etsy so that you can make the most of this brilliant platform.

So, let us get started without further ado!

CHAPTER ONE

WHAT IS ETSY?

History of Etsy

Etsy is one of the most popular e-commerce platforms these days that, in essence, is a P2P (peer-to-peer) selling website for handmade and vintage items. The items sold on Etsy include exclusive as well as unique vintage items. A wide variety of items can be sold and purchased on Etsy like art, clothing, jewelry, different knick-knacks, quilts, handmade and vintage toys (including antique items), photography and even different bath and beauty products. The primary goal of Etsy is to create an e-commerce platform that allows sellers to showcase any handmade items like the ones that are usually displayed at traditional craft fairs. Etsy is merely a digitized and virtual platform with all the quirks of a traditional crafts fair. By 2014, Etsy had over 50 million active users across the globe and over 1.4 million registered sellers. Etsy has more than 700 employees and managed a sales turnover of over 25 million by the end of 2014.

Etsy was launched in the year 2005 by Haim Schoppik, Robert Kalin and Chris Maguire. It took about two and a half months to create the initial version of the Etsy website. After a while, another member joined the group of owners- Jared Tarbell. Maria Thomas was appointed as the COO of Etsy in 2008 and was quickly promoted to CEO. By the end of 2009, Maria bid adieu to Etsy. Around this time, Robert Kalin had taken over the role of CEO and held this post until 2011. Two of the founders of Etsy (Chris Maguire and Haim Schoppik) said their goodbyes in August 2008 along with several other long-standing employees. In September 2008, Chad Dickerson, the former Yahoo1 executive was named as the CTO (Chief Technological Officer) of Etsy. In 2011, Rob Kalin was removed from his position, and Chad stepped in as the CEO. Etsy declared its B Corporation certification in May 2012 and managed to raise a capital of around $40 million in F Series funding. Toward the end of 2016, Etsy acquired an Artificial Intelligence venture named Blackbird Technologies.

The headquarters of Etsy is located in Brooklyn, New York. The headquarters in Brooklyn also house Etsy's communications and business, PR/marketing, customer support and technology departments. Etsy Inc. officially owns Etsy. Even though Chris Maguire, Robert Kalin, Haim Schoppik and Jared Tarbell are the original creators of Etsy, Chad Dickerson is the CEO, President and Chairperson of Etsy.

Etsy is an online marketplace that allows sellers to sell and showcase any of their handmade and vintage items. The one factor that makes Etsy different from other online marketplaces is the uniqueness of all the items sold on it. It deals in genuine as well as unique handmade arts and crafts. Etsy charges a listing fee of about $0.20 on every item along with a 3.5% commission on every sale made. Etsy has continued to grow and develop since its inception steadily. The scope of this e-commerce platform is on an upward curve.

If you are looking for a platform deal in handmade or vintage items, it can be rather tricky to create a viable sales platform by yourself. This is precisely what Etsy will help you with. As with any platform, there are specific pros and cons of listing yourself as a seller on Etsy and you will learn about them in this section.

Advantages of having an Etsy Business

Wide Reach

The potential of driving web traffic to your store increases when you use Etsy. If you have your website, it might take you a while to establish the level of traffic that Etsy can provide you with in no time at all. Etsy boasts of millions of active visitors who visit the platform every month looking to purchase specific items.

Quite simple

It is quite easy to get started and you can create an Etsy storefront within 15 minutes! It certainly takes a while longer than that to create a customized website. However, when you opt to use Etsy, you have access to different templates and samples that help you design a virtual storefront within no time. Instead of having to deal with various aspects of creating a website like a font to use or the credit card processor you need, Etsy allows you to focus on the essential elements of business like the items that you want to list on your store and so on.

Plenty of resources

If you manage to use all the resources available to you optimally, then you can join the ranks of Etsy sellers who manage to rake in thousands of dollars as income from Etsy. You can learn from the success stories of different Etsy sellers to build up your online brand. You will learn more about the various tips you can use to create a successful Etsy store in the following chapters.

Collaborative community

A beautiful thing about Etsy is the community of sellers it has. Different sellers tend to freely share their tips about do's and don'ts to make the most of Etsy. You can contact a mentor for yourself or even mentor others and earn income while doing something that you love and enjoy.

Work at your pace

Once you have your Etsy store up and running, you can start working at your own pace and time. It is one of the best ways in which you can earn passive income after you systemize the entire store and operations.

Listing Fees

Etsy charges a listing fee of $0.20 per item and the item stays active for four months. It essentially means that you will be shelling out only a nickel per item that you list. It is quite economical, and you can renew the listing once again.

Disadvantages of having an Etsy Business

Saturation

There has been an online explosion of different platforms that offer handcrafted and vintage goods these days. So, online competition has undoubtedly increased in the last decade. You must ensure that you stand out from other sellers if you want to establish a successful Etsy business. Etsy is quite economical, and this means that the level of competition is quite high too. As long as you choose your niche carefully and offer good-quality products, you will be able to beat your competition.

You will need to find a niche that suits you and the requirements you have in mind. When you do find a niche that you like, type the same into the search bar

that's provided on Etsy. This will help you in checking the competition that exists. Since you are just getting started with niche selling, make sure that there isn't too much competition. If not, you may have a tough time while selling. Look into different sub-categories of niches as well. Even if it sounds eccentric, it might be lucrative. Do a lot of research and don't just stick to the most obvious options that are available online.

Copycats

You must remember that there will be other businesses that might duplicate your listening or images. It can be tricky to prevent this from happening unless you can establish that the other seller is a copycat. To set yourself apart from all the copycats that exist, you must ensure that you are offering unique and brilliant products.

Fees involved

Even though the listing fees charged by Etsy are quite economical, you must consider all the other overheads involved too like the PayPal fees or the cost of any inventory you hold. All the different variables involved in selling your products must be analyzed carefully before you decide to go ahead and set your shop on Etsy.

Branding

On Etsy, you have the option or creating a unique banner for your store and customizing your listings. Apart from this, everything else offered is standardized

and it means that the final look might or might not be something you are fond of.

Control

Since you are using Etsy as the selling platform, it gives Etsy control over everything that happens at your store. Etsy can shut down your store if you violate any of its policies and this can be done without any warning.

Undercut your prices

A popular way in which new sellers often take over the business from other vendors is by undercutting their prices. Even if your pricing is quite reasonable and your profit margin is slim, there is always a chance that some other seller might sell similar products at a lower price. To avoid this, you must keep tweaking your business structure regularly to stay ahead of your competition.

The advantages of starting a business on Etsy outnumber the disadvantages. In fact, with a little preparation and a good business strategy, you will be able to optimize your Etsy business and start earning a good income.

Setting Goals

Before you start any business, you must have specific goals in mind. Having a goal like "better sales," or "earn more income" isn't the most actionable of goals. In this

section, you will learn about ways in which you can set goals.

Steps to set goals

When you set goals before you start something, it helps increases the chances of achieving your goals and reduces the instances of procrastination. If you don't set SMART goals for yourself, it is quite likely that you will end up abandoning them. SMART is the acronym that's used to set goals and it refers to Specific, Measurable, Attainable, Relevant and Time-bound goals. Here are a couple of ways in which you can set SMART goals for your Etsy business.

The goal must be specific. So, you must opt for a particular area to concentrate on at any given point of time. A common goal can be "I want to work on SEO," whereas a SMART goal will be "I will start rewriting the product descriptions on my ETSY listing to improve the SEO visibility."

The next step while setting goals is that the goal must always be measurable. You can use the stats that Etsy provides or any other analytical tool like Google Analytics to track all the data to measure your progress. For instance, a common goal will be "I want to improve my sales." Whereas a SMART goal will be, "I want to increase my total sales on Etsy by 25%."

If the goals that you are setting for yourself aren't attainable, then you are setting yourself up for failure. If

your goal is to sell at 1000 items in a year, then you can break this down into smaller and attainable goals like I want to sell at least 85 articles per month. So, every time you attain a monthly goal, you will be a step closer to realizing your annual goal.

Now, the goals you set must also be relevant to your line of work. What might work for other sellers or the things that might be relevant to other sellers need not apply to your business. For instance, if you are aware that most of your target audience is on Instagram, then it doesn't make any sense to spend your resources creating and running a brilliant ad campaign on Twitter.

The final aspect of a SMART goal is that the goal needs to be time-bound. You need to set a time limit within which you want to attain your goal. If you don't set a time limit, it is unlikely that you will work on achieving that goal. Not just that, without a time limit, you will not be able to measure any progress you make. So, a common goal might be "I want to increase the items in the listening." Whereas a SMART goal will be "I will add another ten items to the listing every month."

Once you start setting goals using the SMART technique, the next step is to focus on the kind of goals you can set.

A brand-new store

If you are setting up a store on Etsy, then one of the most straightforward goals you can set for the store is

"make one sale from a total stranger." Why is this an example of a good goal? This goal is more actionable than the goal that states "make a sale." This goal is quantifiable since it prescribes that you need to make "one" sale and your target audience is described too. The more details your goal has, the more actionable will it be.

Around a year

If you have been in the Etsy business for a little over a year, then you must take a look at the sales from your previous year and set a benchmark for yourself. Look at your sales turnover from the last holiday season and select a milestone. You must choose a reasonable percentage and stick to it. You can think about increasing your revenue or overall sales or both. For instance, if you managed to make 100 sales during the previous holiday season, then you can set a goal to increase your sales by 20% this holiday season. If you made 100 sales last year, then according to this goal, you must make at least 120 sales this year. As long as the number you set for yourself is attainable, you can work towards attaining it.

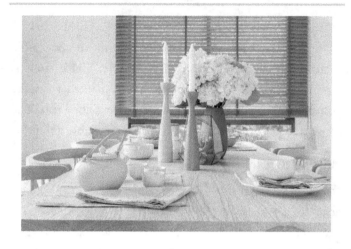

CHAPTER TWO

UNDERSTANDING ETSY'S BUSINESS MODEL

Register Yourself on Etsy

Registering yourself on Etsy is not only comfortable, but it is also free! Once you register yourself as a seller on Etsy, then you can start curating the listings for your Etsy store, post in the community and start using the different features that Etsy offers. Here are the steps that you must follow to register yourself on Etsy.

Step One: Go through Etsy's Privacy Policy and Terms of Use. It is quintessential that you do this since it provides the essential guidelines about the practices that are considered to be desirable and undesirable on Etsy. If you violate any of these rules, then Etsy can deactivate your account.

Step Two: Once you go through all the policies, you must click on the "Register" option present on your screen.

Step Three: You will be directed to a form to fill out all your details.

Step Four: Once you fill out all your details, you will get an email from Etsy to your registered email ID to confirm the same. Open your concerned email account and click on the mail to confirm. Once you do this, you will receive a confirmation mail from Etsy within no time. Open this mail and click on the button that's attached to the email to confirm your account. If you cannot see the confirmation mail, then please check the spam or junk folder. If you use Gmail, then check the Social and Promotions option to see the mail (if you don't find it in your inbox).

Step Five: Now that you have confirmed your email id and have registered yourself, the final step is to log into your Etsy account.

Once you register yourself on Etsy, the next step is to open an Etsy shop. Etsy is a massive marketplace and you can pretty much sell anything you want, as long as it is not in violation of the Etsy's policies and terms of service. If you are just getting started with Etsy, you might be a little overwhelmed initially. Well, opening a store on Etsy is quite simple and straightforward. You merely need to spend some time and carefully go through the different options, and that's about it. You will learn more about this in the coming chapters.

Policies

Etsy is an extensive marketplace for selling handmade products, vintage items or goods as well as craft supplies. The great thing about Etsy is that the sellers can directly sell their wares to buyers across the globe. Etsy has specific policies in place to ensure that both the buyers and sellers will have a positive experience on their platform. In this section, you will learn more about Etsy's policies.

The Terms of Use as dictated by Etsy include different guidelines about the goods that can and cannot be sold on Etsy, about representing yourself, your listings and your Etsy store, rules about creating and uploading content, about the review system, customer service and other aspects of a business.

What can be sold on Etsy?

Etsy is a unique platform wherein most of the buyers are looking to purchase such items that they cannot find elsewhere. Everything that is listed on Etsy for sale must fall into one of the three categories- handmade, craft supplies or vintage.

All items are believed to be handmade if you either make and design them or are designed by you (the seller). If you are selling any handmade items, then you agree that all the items are made or are designed by you. If you are partnering with a producer, then you need to disclose the

information about your production partner in the concerned listings. You need to give an accurate description of all those who are involved in the production process of a relevant item in the About Section of your Etsy shop. You must ensure that the photographs you are using are the ones of the product and aren't photos used by other sellers, sites or are stock photos. The pictures of the products listed must not be artistic renderings and must give the viewer an exact idea of what the product looks like.

If you are dealing in any personalized or customized items (a subcategory in the category of the Handmade item), then you essentially agree that all the listings you provide can be availed at a specific price. If you do use any photographs of previous works with variables for customization like color choice and such, then you must include a note in your listing that the products shown are mere examples.

An item is considered to be vintage if it is at least 20 years old. Craft supplies are the term that's used to denote any tools, materials or ingredients that can be used for creating or crafting another item. Craft supplies can be handmade, commercial or even vintage. Etsy allows sellers to sell party supplies also under the category of craft supplies. Etsy tries to create a somewhat transparent environment for conducting sales. So, all sellers have the option of listing any attributes of their listing. It means that you can also

include information about the way the craft supplies were sourced or any other unique characteristics of the items like organic, cruelty-free and such can be mentioned in the description of the products listed on your Etsy store.

What cannot be sold on Etsy?

Etsy is undoubtedly a curated marketplace, but there are certain items that you cannot sell on Etsy. There are some items that present legal risks, are against the spirit of the platform or are believed to be harmful. The Terms of Use of Etsy provides a list of items that cannot be sold on Etsy.

You cannot sell the following items on Etsy:

All products that can be easily classified as drugs or alcohol cannot be sold on Etsy. A seller is prohibited from selling any intoxicating drugs, controlled substances, substances that contain alcohol or tobacco, drug paraphernalia (like bongs, carburetor, vaporizers or any of their components), and other medical drugs.

Certain animal products or anything containing human remains cannot be sold on Etsy. This list includes live animals, items made using species considered to be endangered or severely threatened, items curated using ivory and/or bones derived from ivory-producing animals and all items made from human remains (this doesn't include items made from teeth, fingernails and hair). So, a seller is free to sell leather goods, textiles

made from animal hair (a mohair scarf or a skilled garment), or wigs.

A seller is prohibited from selling hazardous items like explosives, flammable goods, gasses, radioactive materials or things that include radioactive materials and toxic substances. However, a seller can sell knives that are used as tools (culinary knives, letter openers, toy slingshots and airsoft guns).

Any item that's believed to promote, glorify or support hatred in any manner is prohibited from being sold on Etsy. Any item that either commemorates or supports any hate groups (Neo-Nazis, white supremacist groups and the like) is not permitted. Any item that is considered to be racially offensive is banned too. However, you are free to sell religious symbols.

Any item or items that are believed to be illegal, promote illegal activity or are considered to be highly regulated cannot be sold on Etsy. Apart from this, any item that encourages pornography or mature content is also prohibited. Even if the item meets the prerequisites of Etsy's marketplace policies but is considered to violate Etsy's intellectual property guidelines or is believed to be a prohibitory service, then it is not allowed to be sold on Etsy. Also, reselling is prohibited on Etsy. If an item is listed as being handmade, but the seller was neither involved in the designing or the production process of the concerned product, then such an object will fall under the category of "reselling."

You must remember that if any member on Etsy flags your listing as violating Etsy's policies, then Etsy has the power to remove such listings. Also, the listing fee isn't refundable. If you do list any items that are prohibited, then you not only risk the termination of your Etsy listing but will also lose the listing fee.

As a seller, it is your responsibility to represent yourself, your store and all your listings in a fair, honest and just manner. Transparency is one of the critical requirements of being an Etsy seller. So, by listing yourself as a seller on Etsy, you agree to:

- Providing honest and accurate information about yourself and the products in the 'About' section of your Etsy store.

- Follow and honor all the Terms of Use as prescribed by Etsy.

- Give an accurate representation of all the items and photos in your listings.

- Accept to respect the intellectual property rights of others and safeguard your rights.

- Not use any duplicate shops to manipulate the Etsy algorithm or engage with other sellers to coordinate the prices and cheat customers.

- If you want to communicate with other Etsy members or buyers directly, then you can use Etsy Conversations. Conversations are an easily accessible and efficient means for potential buyers to talk with sellers about any doubts they have about any item or their orders. You can use conversations to talk, but there are certain things that you must never use chats for. Here is a list of activities for which you cannot use conversations:

- You must not send any unsolicited advertisements, promotional content or any requests for donations or anything else that is considered as spam. You must not interfere with a transaction of any other member.

CHAPTER THREE

BUSINESS ESSENTIALS

Create a Business Plan

A lot of people seem to think that creating a business plan is a challenging and excruciating tedious process. Well, if you feel the same about business plans, then you are wrong. Writing a business plan is not difficult and you will be able to write one in less than an hour. Yes, one hour is all that takes. Also, it is rather engaging and fun to write a business plan. Your business plan describes the strategies and the ideas for selling your products, so it is rather engaging. There is no reason why you must restrain your creativity and try to get as creative as you can. Here are the different steps that will come in handy while writing a business plan.

First things first, what exactly is a business plan? A business plan is a blueprint of what your potential business venture. Why do you need a business plan? A business plan will help gauge the feasibility of your business idea, it acts as a guide and reduces the chances of making any mistakes, helps identify any potential

weaknesses or shortcomings, gives you an idea of the funds you need and finally, it helps to increase the chances of success. Please keep in mind that if you fail to plan, then you are planning to fail.

A business plan doesn't have to be a 100-page document filled with charts, graphs or anything like that. A business plan can be restricted to just one page, provided it gives a brief description of all the essential aspects of your business. Follow the Twitter policy of not exceeding 140 characters while writing the descriptions and your work will become quite simple. The business plan must offer information about ten aspects of business and they are as follows.

The first thing to include in the plan is your value proposition. Give a brief description of what your business is about.

What is the problem that your products address? It primarily refers to the market need you wish to satisfy with your products.

You need to give a short description of the products you wish to sell. This will help identify whether the products you want to sell will fulfill any existing market needs or not.

Who are your competitors? Are there other sellers on the market selling products similar to your products? If yes, are the products more superior to the ones you want to sell?

Who is your target audience? Who are your potential buyers and will they be interested in buying your products?

What is the cost that you will incur for producing or selling one product? This portion of the business plan is primarily related to your budgeting and sales forecasting.

How do you plan to market your products? What are the sales channels or marketing activities you wish to undertake?

Are there are milestones or business goals you have set? What do you want to achieve?

Why do you think you are the right person for the job and do you have a management team in place?

The final aspect of your business plan must address these simple issues- how much funds do you need, what will you use the funds for and how will you raise the necessary funds? (This question is optional)

While you are brainstorming about all these things, you must not think of it as writing a business plan. A better way to go about this is to think of all these things as the essentials of a business pitch. A business pitch certainly sounds more exciting than a business plan doesn't it?

Here is an example of how you can write a business pitch in less than an hour for an imaginary business venture. Let us breakdown the business pitch and write the

descriptions for all the ten items that were discussed earlier.

Value proposition: First things first, what is your value proposition? If you were to write a tweet of fewer than 140 characters explaining the essence of your business, what will you write? Think about what your business is about and what makes it unique? Try to keep this brief and inspiring. After all, the idea to stand out from the rest of the businesses, isn't it?

The market need: If there is no market need you to wish to fulfill, then it means that there is no market for the products you want to sell. If you are not sure whether there is a market for the products you are offering or not, then you can do a quick survey. You can ask your friends, colleagues or even conduct a random survey to see whether others will purchase your products or not.

What you offer: Now that you are sure that there is a market for your product, the next step is to describe why you think your product will work. Well, if someone was to ask you, "what do you sell?" what will your answer be? Try to make this as convincing as possible.

Target market: You must be as specific as you can be about your potential customers. For instance, whom do you wish to sell? Who will be interested in buying your products? You can establish specific demographical parameters to understand your target audience. Once you have defined the problem and have come up with a

solution for the same, the next step will be to identify your potential customers. In this part of the pitch, you will have to define the audience you are catering to. Try to divide your target market into small segments and it gets easier to target them. It is quite tempting to let your target be as big as possible, but that doesn't help while making a business plan. If you want to sell vintage hats, then you cannot state that your target audience is "everyone." You need to come up with a specific audience. If you are selling bohemian hats, then maybe your target audience can be women between the age groups of 15-30 years.

Competition: There will always be competition on the market. If you notice that the niche you opt for has several well-established sellers and the competition is quite high, then it is a good idea to reconsider your choice of niche. If the competition is too high, then you might not be able to get a breakthrough in such a market. Also, if the competition is too high, it implies that the market has reached its saturation point. On the other hand, if there is absolutely no competition whatsoever, then it means that your business idea isn't all that good. The niche you select must have moderate competition. Once you identify your competition, you must make a list of reasons why you think your products can attract customers. There is an alternative available for every problem. So, in this section of the plan, you will need to think about all the advantages that your products offer

when compared to your competitors. Tell your audience why they must choose you and not the other sellers.

Funding: You might need some funds to start your business. Please ensure that you have a clear idea of all the funds you will need and how you can raise funds needed. Also, if you wish to borrow to meet your funding needs, have a plan in mind for paying off the debt too.

Sales channels: Where do you wish to sell your products? Well, this is an easy question to answer- Etsy! You can sell products on Etsy if they are handmade, vintage or are craft supplies. If the products you wish to sell don't fall under any of these categories, then it is time for you to reconsider your selling platform. Also, you can always use multiple sales channels. For instance, you can sell your products at a local craft fair or even a small boutique.

Marketing: In this digitized world, you need good marketing if you want to become a successful seller. What are the different ways in which you wish to market your products? You can use Search Ads on Etsy, create a blog or even promote your products or Etsy store on other social networking sites.

Projections: How much will it cost you to make a product? What is the time frame within which you can sell the products? What are the marketing costs involved? If you can answer these questions as accurately

as possible, then you have your financial projections in hand. The financial summary doesn't mean showing or presenting an elaborate five-year plan. It is essential that you understand your business model well. The business model might sound slightly complicated. However, it is quite simple. You must have a rough idea of the expenses you will incur along the way and the income you will earn. A likely sales and budget forecast or estimate is what you need.

Goals: What are your business milestones? What have you achieved so far? Your business milestones can include things like the schedule for purchasing supplies, creating a business pitch or anything else that you think is essential for propelling your business ahead.

Management: Do you have a partner, or will you be managing everything by yourself?

Once you manage to answer all these different questions, you will have a business pitch in hand.

Make a Checklist

Here is a checklist of all the things that you must have if you want to run your Etsy business successfully.

Professional email address

You can undoubtedly use Etsy for messaging other sellers in your niche and your customers. However, it is quite likely that you will need to use your email to contact other customers, potential customers, vendors and any other interested parties. So, you need to create a professional email address. Yes, you need a professional email address. You need to create something along the lines of nameofyourshop@emailaddress.com or something easily recognizable. You can use any email service of your choice, as long as the email address sounds professional. Once you register your domain

name, you can update the address so that the second half of the id is the name of your business. This will not only lend an air of professionalism but will also come in handy while organizing your business contacts and messages.

Domain name

Even if you don't have a website or aren't ready to create a website, it always helps to purchase a domain name. According to the domain name that you want to purchase, the cost will vary. You can purchase a domain name for an annual fee of something as low as $15. It is a good idea to have a domain name ready so that you can set up a website whenever you want to. Even if the website includes nothing other than necessary contact information and a link to your shop, it does the trick.

Social media

We live in a digital world that's dominated by social media networks. You can use your shop name and create official accounts for the same on different social media platforms like Facebook, Instagram, Twitter or anything else that's popular with your target audience. Add an appropriate profile picture and start posting content that's relevant to your store. For every picture of the products you post, ensure that you provide a direct link to your Etsy store on the post. Just like the domain, even if you aren't active on social pages, it always helps to have the contact information of your Etsy store available on different channels.

Business branding

You need to concentrate on not just creating and selling products on Etsy, but you must also focus on establishing your brand online. If you are not sure what branding entails, don't worry. Branding mainly refers to the process of creating a distinct name and image for a specific product in the mind of your customers. For branding, you need to ensure that you are advertising your store and are using a consistent theme. For instance, the minute you see a bright yellow shiny M on the highway, it will automatically remind you of McDonald's. Likewise, you must start using different visuals and imagery like your store's logo to start branding. The store's logo is reminiscent of your mission statement; the motivation for doing business and it conveys the story of your business to the audience in an effective manner. You can either outsource this work to a professional or even do it yourself. During the initial phases, it might be rather expensive to hire a professional. However, it all depends on your budget and you can take it from there.

Setting goals

You must set some goals for your business. Keep the tips mentioned in the previous chapter about setting goals in mind while establishing goals for your business. It always helps if you can write down your goals instead of making a mental note of them. The ideal practice is to set monthly, quarterly and yearly goals for your business.

You can get as creative as you want while setting goals. The only thing that you must keep in mind is that your goals are attainable. If you set unattainable goals, then you are merely setting yourself up for disappointment. Once you establish your goals, it is time to start working actively toward achieving those goals.

Product photography

If you want to establish and run a successful store on Etsy, then one thing that you cannot afford to skip is product photography. The product photos you post can make all the difference between closing a deal and a potential customer moving onto the next store. You must understand that humans are visual beings. For instance, when you go shopping, isn't it most likely that you will decide to step into a store that is aesthetically pleasing and has well-dressed mannequins on display? Likewise, if the product photographs you post are of good quality, it is quite likely that the customer will be curious to browse through your listing. It can take you a while before you get the hang of clicking the perfect product photos for your listing, but you will get there if you keep trying. Try changing the lighting, work on editing and styling the products to make the photos visually pleasing. As long as the product photo isn't exaggerated and displays what the product looks like, you will be fine. Posting high-quality images of products will certainly take you a step closer toward making more sales.

Don't stop creating

Nothing in this world is constant. So, why must your business stay dormant? You must keep changing your marketing and advertising techniques. Not just that, you must also keep updating your listing and keep adding new products to your listing. While starting an Etsy business, you must ensure that you have a couple of new product ideas.

Organize

You must always organize your finances. Bookkeeping is quintessential and so is filing your taxes. So, from the get-go, you must ensure that you have everything organized. Not only will this save time in the end, but it will also help you understand how much you are spending and earning. If your finances are not in order, you will find yourself in a world of trouble that can have easily be avoided had you just organized your finances.

There is another essential thing that you must keep in mind and never forget to have some fun! If your business becomes tedious and tiring, then you will soon lose the interest to keep going. Don't forget that you started your Etsy store to earn money while doing something that you enjoy!

Choosing a Business Structure – Sole Proprietor, LLC, S-Corp, etc.

Once you have decided that you want to run a proper business instead of just indulging a hobby, then you

must be clear about the kind of company you want to establish. There are various business structures that you can choose from and you will learn about them in this section. According to the state you reside in, you might need to obtain a business license for running an Etsy store.

Sole proprietorship

As the name suggests, in this type of business structure, you will be the only proprietor. You must understand that you can certainly start a business within the US without having to sign any documents officially. It is the activity that you undertake which defines whether you are running a business or not. So, if you start an Etsy store and make your first sale, then it means that you are now officially running a business! If you do this, then the resultant business can be termed as a sole proprietorship and you will be the singular owner of your Etsy store.

Since you are the sole owner, you will not only be entitled to all the profits that your business earns, but the responsibility to shoulder all potential losses will also fall on you. It means that you will be singularly responsible for all the profits, losses and the liabilities of the business. The sole proprietor usually has unlimited liability. So, in the event of your company going into losses, you will personally be liable for paying off the debt.

There aren't any specific business taxes that must be paid by a sole proprietorship company. Since the owner and

the business are considered to be a single entity, the taxes that the owner pays on income from the business will be a part of the owner's personal tax payments. There isn't any official documentation that you need to file out before you can start your business, it is always a good idea to ensure that you are not in violation of any licensing, regulation or zoning laws of the state you reside in.

If you decide to do business under any other name or have a fictitious name for your business, then you must make sure that you are filing all the necessary applications under the said name.

The advantages of this form of business are that there are barely any startup costs involved, you will have complete and sole control over the business and all business decisions, you can transfer or even sell the business, you don't have to pay any corporate taxes and there are no formal business requirements. On the downside, if you do decide to opt for a sole proprietorship, then please be prepared to shoulder any liabilities and obligations of your business and mentally prepare yourself to bear the consequences of all the business decisions you make.

Partnership

You can either opt for a general partnership or a limited partnership. A general partnership is a form of business that has one or two partners or co-owners. Usually, the partners in a general partnership will agree to share the

profits and losses equally. However, it doesn't always have to be like this. For instance, if you and your friend decide to form a partnership and you invest more than your friend for the startup capital, then you can agree to split the profits and losses according to the ratio of your capital contribution, like 60:40. General partnerships are quite similar to sole proprietorships with the only difference that you will be sharing your profits and losses with another partner. All the partners in a general partnership will be personally liable for any debts that the business incurs.

There is another form of partnership and that's a limited partnership. In this case, one partner can contribute the funds and will share in the profits made, but doesn't assume any working role in the business. It's like having an investor for sharing the costs of business while there is only one partner who takes an active role in the day-to-day workings of the business.

Corporation

A corporation is a type of business wherein the corporation is deemed to be a legal entity on its own, and it has a separate legal entity from that of its owners, managers and employees. You can start a corporation by yourself or even have someone else on board with you. By creating a corporation, you can safeguard your personal assets and ensure that you don't incur any personal liability even when the corporation is sued. There are two types of corporations, and they are C-

corporations and S-corporations. C-corporations provide financial protection to all its stakeholders, while S-corporations are relatively economical to start and easier to maintain. Therefore, a lot of small businesses decide to opt for the S-corporation structure.

Limited Liability Company

An LLC or limited liability company is one of the most popular forms of business these days. This business structure is a hybrid of a partnership and a corporation. As the name suggests, your liability will not only be limited, but you will also have the option to choose whether you want to treat the business as a corporation or a partnership. Your answer to this will depend on the tax liability attached to the form of business you decide to opt for. The advantages of an LLC are that your liability will be limited to your capital contribution, your personal assets will be safeguarded from being liquidated if things don't go as planned and it seems more credible than a regular partnership.

Before you decide to opt for a specific business structure, it is a good idea to consult your financial advisor to ensure that you are on the right side of law and aren't breaking any rules.

Working on Your Brand

Most of the sellers on Etsy don't know how to utilize the branding options that the platform provides fully. In this section, you will learn about five different ways in which you can brand your Etsy business to increase your brand's presence. Before delving into how to go about branding, the first thing you must understand is the importance of branding your Etsy business. There are different reasons to brand your business, but the most popular ones are as follows:

It makes it easier to attract customers. It helps to exist as well as potential customers to recognize your products as well as your business rather quickly. It helps establish

a credible and loyal customer base. It enables the customers to relate to you as well as your Etsy business. The most crucial advantage of branding is that it sets your business apart from all the other tens of thousands of sellers listed on Etsy.

So, how do you go about branding your Etsy business? Branding certainly isn't restricted to colors and fonts you use, but this is undoubtedly an excellent place to get started.

Logo and header

Your logo, as well as the header image you decide to use, must be in sync with one another. They must create a vibe that you are aiming for. You can use these graphics to establish your brand- something that you know will attract your target audience. The first step is to select the font you want to use in the logo and the header image. You can opt for one or two fonts, and once you do this, please ensure that you stay consistent in using the fonts. Specific fonts tend to convey a specific look and feel, to ensure that the font that you opt for matches your Etsy business. For instance, if you wish to sell bohemian accessories, then it doesn't make any sense to use bright primary colors in your logo. Likewise, if you want to sell whimsical stationery, then it will look rather absurd if you opt for bold and gothic styled fonts. If you aren't sure of the look you are going for; then you can use simple online tools like PicMonkey or even Canva to get a feel of the final image. Apart from this, you can also go

through the logos and header images of your competitors on Etsy to get some inspiration. Another available option is to hire a professional designer to help create a logo or header image for your Etsy store.

Product photography

If you want to work on branding, then you must try to establish a cohesive look by concentrating on the store's logo, header image, and product photography. The aim is to create a specific look or vibe by using product photos. So, if you want to sell vintage baby clothes, then it doesn't make any sense to use neon colors as the backdrop for product photos. Even if you are interested in only using a white colored background, it is quintessential that the shade of white you opt for is the same. Yes, you read it right; there are different shades of white like egg-white, ivory, off-white and so on. According to the lighting, the shade of white can differ. So, you must ensure that the color scheme you decide to use is the same. You can use tools like Creative Market to create a mockup of your product photographs.

Products listed

Some Etsy sellers are quite adept at mixing and matching their products to create visually pleasing aesthetics. However, such sellers are quite rare to come by. If you are just getting started, then it is a good idea to opt for one type of item and sticking with it, at least for a while. For instance, if you want to sell handmade dolls, vintage gowns and art prints in the same Etsy store, then the

product listing will seem quite chaotic and all over the place. It will end up confusing your customers and will make it rather tricky to create a brand on Etsy. However, if you decide to sell hats, mittens, and scarves in the same store, it does go well together. Remember that there needs to be cohesiveness to whatever you decide to do, especially if you want to work on branding. Another aspect of product listing that you can concentrate on for creating a brand is the product descriptions. For instance, it doesn't make any sense to use a boring and dull product description if you are selling sarcastic and witty greeting cards. You must try to infuse a little bit of your personality into your Etsy store while creating a brand.

About page

The same rule that has been mentioned over and over again in the previous sections applies to the about page as well. While filling out the "about" page for your Etsy store, ensure that you are using such words and phrases that not only describe your business as well as your products but go well with the brand you are trying to create. You will be surprised that a lot of Etsy shoppers appreciate handmade items and most of them will be quite interested in getting to know more about the business they are buying the items from. So, this isn't the time to step away from the limelight. Include some tidbits of information about yourself and your motivation for doing what you do to pique the curiosity of your shoppers.

Social media profiles

Another simple way in which you can work on branding is by concentrating on creating a brand on social media profiles. You can create official profiles for your business on different platforms and use the same logo, name or taglines on all the platforms. The photos and the content that you upload on various platforms must have the same look and vibe as the ones that you used in your Etsy store. Doing this will help create a cohesive brand for your Etsy store.

CHAPTER FOUR

STARTING AN ETSY BUSINESS

Open an Etsy Store

Opening an Etsy store is quite simple, provided you know what you need to do. Here are the steps that you can follow to open an Etsy store.

Step one: Get started

The first step is to create an Etsy account. If you have followed the steps mentioned in the previous step, then you have a new Etsy account.

Step two: Shop preferences

Now, you must select the default language for your page. The default language is the one in which all the listings and product descriptions will be visible on your page. If you want, you can always translate the information on your page into any language of your choice. Then, you need to set the home country along with the currency for the listing.

Step three: Shop name

This is the time to get a little creative. You can come up with a shop name that is unique and intriguing while

being easy to remember. Not just that, it must also represent what your store and the products you sell are about. The name can be anything you want, provided it is about 4-20 characters in length, doesn't include any special characters or spaces, doesn't infringe any trademarks or copyrights, doesn't contain any profanities and isn't already in use. You can always go through the Etsy profiles of your competitors to come up with an ideal shop name.

Step Four: Add items

You need to start adding items to your store before you can start selling any. The first step in the listing is to add photos. It is ideal that you use at least five photographs per item so that the customer can view the product from different angles. Etsy recommends that each image must at least be 1000 pixels square (it essentially means that you must use high-quality images). Then you need to adjust the thumbnails for every listing. The thumbnail is the first picture of the item that the customer will view whenever they see the listing or when they search for it on Etsy. The thumbnail is similar to a headshot of the product you list, to ensure that the thumbnail is clear and easy to view. You need to give a product description of every item that you list. The product description must be restricted to 140 characters. So, within these 140 characters, you must try to give an as clear and thorough description of the product as you possibly can. You can describe the form of bullet points and add certain additional information like the category and the type of

product you are selling. You can use 13 tags per item listed. The tags are the relevant keywords that correspond with the listing. Shoppers usually search for items using keywords, and if you use the relevant tags, it improves the visibility of your listing.

You need to enter details about the product like its price, quantity, any sales tax (if applicable) and any variations available. Once you do this, you need to set the shipping costs too. In this section, you need to include the necessary shipping charges payable, the country of origin, time taken for delivery and processing and the weight or size of the item. After you successfully fill in all these details, you can preview your listing. Once you are happy with the preview, you can publish the listing.

Step five: Payment and billing

You need to select the forms of payment that work well for you. There are different options to choose from like PayPal, money order or any "other" modes of payment (this includes different forms of payment like store credit, gift cards, credit cards and debit cards). According to the country you are based in, Etsy might require additional information like your credit card details for the sake of authorization. You will also need to attach a card to your Etsy account to pay for any charges levied by this platform like the selling fees.

Step six: Open your store

Once you complete all the above-mentioned steps, your Etsy store is ready! Now, you need to start customizing your store. Your work doesn't end after you create a primary Etsy store. As with a regular brick-and-mortar store, you need to customize your digital store to make it more attractive to your customers. Also, you need to always keep updating and tweaking the store according to your needs and current trends.

You need to add a bio and a photo. Your Etsy profile gives the visitors information about you and your store. In your bio, you can include some information about yourself, your products, your aim, the story behind your store and even your qualifications. You need to establish your store policies. In this section, you can answer any common questions that the customers might have about the shipping, return, cancellation and payment processes. You must include an estimated processing and shipping timeframe in this information so that the customers know how long it takes for the products to reach them. It is quintessential that all the information you add in this section is clear and unambiguous. You will learn more about all this in the following chapters.

Things to Keep in Mind

If you want a platform that helps you channel your passion and display your skills while earning a viable income doing the same, then Etsy is the best platform

for you! Here are all the things that you must keep in mind while starting an Etsy business.

Test your idea

You may think that you have a great idea, but that does not mean that the market should agree with you. Now is the time to review all the assumptions you include in your business plan. If you want to reduce the starting risk, you need to review your idea. Testing an idea is a tedious and complicated process. It takes a lot of planning, and you have to think about it carefully. Here are some ways to test your idea.

The first method is an interview with a customer. You need to conduct a random interview with the target audience and understand the problem that your potential product or service can solve. You can learn a lot from these interviews. Try to understand how big the problem is for them. Will they use your product or service to solve them, how effective will the current solution be, and what is it worth to solve the problem better? If your business idea is product-based, you can develop a prototype. You can evaluate the reaction of your potential customers and make any necessary changes. You can also see for yourself whether the product works as intended or not. The third method is to conduct surveys. Surveys are the easiest way to reach a broad audience in real time with little effort. A survey is simply a continuation of an interview with a customer. It is almost impossible to interview many customers. The

survey is quite simple though. There are several online tools that you can use to conduct a survey. Make sure the questions you include in the survey are not open. The best survey format is to ask the customer multiple-choice questions.

An attractive storefront

There are a couple of different ways in which you can easily personalize the storefront on Etsy. Personalization is one of the simplest ways in which you can ensure that your store stands out from your competition. Not just that, it also helps grab the attention of all your potential buyers while increasing your brand visibility. You can add a banner to your Etsy storefront. A banner is a simple graphic that runs across the store's page. It is quite easy to design a banner, and you can use different tools like Picasa, Photoshop or even Paint to design a storefront banner. You must include the shop's title on your storefront. The shop title is akin to a tagline, and it will necessarily give a brief overview of what your shop is about. Shop announcement is the space that's available toward the top of your Etsy's shop page. You can use this space to provide valuable information to your shoppers- about any sales, unique offerings, sharing your store policies and so on. You can use different sections to organize the goods you wish to sell. There are various items you can decide to sell. For instance, if you wish to sell items like pens, papers, notebooks, magnets or picture frames, then you can categorize them as stationery, and you can use various filters like size,

type, materials and price to make it easier for the customer to browse through them. You also need to create a profile picture for your storefront. While selecting the profile picture, you must ensure that you are selecting something that goes well with the theme of your store and gives the viewer an idea of what your store is about. It must be such that it reflects not just your personality, but your store's character too.

Pricing your work

When you begin to sell your products or goods in your Etsy store, you might wonder, "How much do I charge for the products?" Well, this is a fair question, and you must decide the pricing before you can go ahead and start selling the items. If you want to have a profitable Etsy store, you need to look at a few numbers and calculate your pricing strategy a bit. There are two simple things that you must learn, and these are certainly not complicated.

The first is (materials + labor + overheads) X2 = wholesale price and the second is the wholesale price X2 = retail price. Shipping costs are not included. The second formula can be customized according to your wishes. If you multiply the wholesale price by 2, you will receive a retail price. Sellers sometimes choose a number greater than 2, such as 2.5 or 3, to determine their selling price, provided that the market is prepared to pay those costs.

Creating product photos

Photos of well-photographed products can boost sales of your Etsy store, but you do not have to hire a professional photographer to do so. You can easily create your photos. Here are a few pointers that will help you get the most out of your product. All you need is a bit of artistic talent, some patience and the following recommendations. You have to tilt the camera; this means that you have to tilt the camera slightly so that the object slightly deviates from the center and generates motion and flow. This will give an interesting picture. Make sure you fill the box with your product so that it not only looks more attractive but also lets potential buyers see how well your product has been processed. To sharpen your piece and give it a touch of sophistication, you can blur the background, automatically shifting focus to your product. Always create a frame with a darker element. You can group your products, especially when designing or making minimal products. To attract attention, you can group multiple products so that the buyer can see how your products are united. Use the rule of thirds. This is a straightforward rule: You must divide the scene you are photographing into nine parts by using two horizontal and vertical lines that look like a tic-tac-toe grid. This will arouse the viewer's interest.

Start composing the titles

The product title is quite similar to a headline for a product you list on Etsy. It must be designed to grab customers' attention and get them to know more about this product. There are some recommendations that you must keep in mind when creating a catchy headline. You need to make it short, and it must not contain more than 155 characters including spaces. Describe all the items at the beginning of the item title so that it helps to increase the visibility of the items. You can become a little creative with words and use puns too. You must always use strong words and don't use ambiguous terms. The idea is to make the viewer curious to read more about the items listed. Also, try not to use too many words in uppercase while composing the titles.

Marketing matters

Etsy is aware of the importance of marketing for the growth of your business. For this reason, several integrated advertising materials such as widgets and coupon codes are included. Marketing and promoting your products will be straightforward for Etsy if you make the most of the following features. You need to create coupon codes for your store. Vouchers will help to increase the awareness of your brand and to provide the necessary rewards for testing your store. This will not only grab the attention of your potential customers but also increase your sales opportunities. You can manage people from other websites by creating widgets. You can

also advertise your shop on various social networks and communicate with friends, family, and fans. Etsy Search Ad is a paid ad space that appears at the top of the search results page when a particular keyword is used.

Set-up

It's easy to become an Etsy seller, and all you have to do is set up your shop and list the items you're dealing with. Before you begin, you must ensure that you have passed the list of items that are prohibited to ensure that the products or services you offer do not fall into this category.

You'll need to click on the "Sell" link that appears in the top left corner of the page. The sales page is displayed. This page contains a list of articles, including articles that you can sell at Etsy and not. Now you must click on the link Open Etsy Shop. When you do this, Etsy automatically prompts you to select a language, country, and currency. The default currency is US dollars, as most Etsy users are based in the US. However, this does not mean that people living in other countries cannot register with Etsy. Etsy supports around 20 types of currencies and various international regions. If you set the store language to English, the currency is US dollars, and the country is the US, you must click "Yes" if all the information you enter matches your needs. If not, you can click on the "Select" link and make the necessary changes. After you make the changes, Etsy saves them and prompts you to select the name of the store. You

must enter the desired name in your store and save all changes. The name you choose will be assigned to your store, provided it isn't already taken by someone else.

Mistakes to Avoid

Etsy is no doubt an excellent platform for selling vintage and handmade products as well as craft supplies. However, if you are just getting started, it can be rather challenging. To make things easier for yourself, you will learn about inevitable mistakes that you must avoid while starting as an Etsy seller.

Not doing sufficient research

Yes, the idea of starting a new business venture can be rather exciting. You might be eager to don the hat of an entrepreneur and start selling your merchandise. Well, all that's good, but don't let this excitement get a firm hold over you until you have done all the necessary homework. If you don't do sufficient research, it is quite likely that you will run into some trouble or the other. You must ensure that you have carefully read through all of Etsy's policies and thoroughly understand the same. You cannot make the most of the platform if you aren't fully aware of what the platform has to offer.

Quality of images

The importance of product photographs is something that can never be overlooked. The quality of the pictures you use is quite remarkable. If you don't have a good camera or don't have the ideal lighting available, then

wait until you do have these things. Whatever you do, it is a cardinal sin to post blurry, dark and grainy images of products to the listing. It simply defies the purpose of wanting to establish a successful business. If it was a physical store that the customers can visit, then they get to try, test and see the product for themselves before they can purchase. However, that certainly isn't the case with an Etsy business, so the quality of images you post is quite critical. If you post pictures of poor quality, then it is highly likely that you will be turning away your potential customers instead of attracting them. Etsy gives you the option of uploading up to five images per item you want to list. Make the most of the space available to you and post good quality images.

Titles and descriptions

A simple thing that a lot of sellers seem to ignore is the importance of titles and descriptions you use. It might not seem like much, but by carefully writing the titles and product descriptions, you can effectively increase your sales. It is believed that the first five words that you use in titles are quite remarkable. The first five words used in the title are likely to appear in a search or even in the HTML address of the specific product.

For instance, if you are interested in selling vintage porcelain dolls, then your title must not be "Beautiful Retro Vintage Antique Porcelain Dolls," because the keyword that you need to concentrate on is dolls and that happens to be the 6th word. This is the one word

that is very important to your listing and that one word will not be present in the HTML address and therefore, the title you chose will not help increase your ranking in search results. So, while selecting the title, you must carefully think it through to ensure that you include the keywords within the first five words of the title.

Not just the title, but also the product description is equally important. Think about the apt description for the products that are not only brief but is quite convincing too. In other words, the description you include must not only be specific, but it must be detailed and exciting too.

Sufficient product listings

It is quite reasonable that a new seller on Etsy might not have more than a handful of items listed on his or her Etsy store. It is always prudent to only list those items that you have an inventory of instead of listing such items that you are yet to obtain a stock of. If you list those products that you have no stock of, it is quite likely that you will lose more sellers than gain any. However, when it comes to listings, you must think of them from the perspective of potential buyers. When a potential buyer views your Etsy store and notices that you have only one page of listings, it is quite likely that the said buyer might think that you are a newbie. When you combine insufficient listings with a handful of reviews, it is quite likely that a potential buyer will skip your store and move onto the Etsy store of a seller who looks more

established and trustworthy. This absence of credibility is one of the trickiest obstacles that you must overcome while getting started on Etsy. To improve the first impression a visitor might have upon seeing your Etsy store is to work on increasing the number of items listed on your store. Well, this doesn't mean that you fill up your Etsy listing with a bunch of random products and items. Everything that you list on the store needs to be cohesive and must not seem haphazard. You can take all the time you need to create or source the inventory that's necessary to increase the product listing on your Etsy store. You can start with a couple of items and slowly increase the listings.

Social media market

Social media plays a rather important role in our lives these days, and the Etsy business you start is not an exception. You must ensure that you are using social media as a marketing tool. If you want to sell something, then the first step is to ensure that you have your target audience's attention. How do you obtain this interest? Well, it is quite simple- you can start using social media to market your business and for creating awareness. You can connect with others across the globe to promote and advertise your brand and Etsy store. Once you start using Etsy, you will notice that this platform allows you to link your Etsy store to your profiles on Facebook and Twitter. There are different tools like the pin-it button that enables the users to pin any of your listed items to their personal boards on Pinterest.

Etsy is a brilliant platform that will help you showcase your merchandise, and you can be a successful seller too, provided you know what needs to be done.

How to Stay Safe on Etsy

One of the critical features of Etsy is the community of exciting and creative people who love it. However, there may be cases where you have a not very pleasant meeting with other participants. As with any other online platform, there are also certain precautions at Etsy.

So that no one can access your account without your authorization, you need a strong password. To create a secure password, certain conditions must be met. It must be at least eight characters, cannot contain your actual name or username, is not a complete word, is different from the previously used passwords, and must be uppercase, lowercase, symbols, numbers, and spaces. You can also change your password every 90 days for added protection. Be vigilant and watch for fraud. These frauds often include payment in the form of personal checks, bank transfers, a significant amount of money for transportation costs that exceed the required cost, or other fees for a foreign request. If you are involved in a scam with Etsy, you must contact your financial institution, report it to Etsy, and you can also contact your local law enforcement agency. Before you switch to a forum or discussion, you must follow the discussions for a while. Take a look at the topic of the discussion and the nature of the conversation. If you think that the

conversation is the worst, you have to disconnect. You do not have to get involved in unnecessary arguments. And the last thing you need to keep in mind is that you must not disclose your contact number or other personal information such as your home or work address. Do not share information that you do not usually share on other social networks. Your safety is in your hands, so please be careful!

Etsy's Do's and Don'ts

There are a few things you must avoid with Etsy. In the end, this is an online store, and there are specific recommendations that you must follow. Every Etsy member must go through the "What may and may not be" page on the site. This page details what you can and must do to avoid a potentially unpleasant incident. To view this page, you must click the link in the top right corner of all Etsy pages, click on the "Site Policy" link and then click on the "What you need and what you do not do" link. Make sure you go through this page to avoid ignoring website policies. Here is a brief description of everything that is included on this page.

Membership is a section where attendees receive recommendations on how to behave on the site. It indicates whether ownership of an Etsy account can be transferred from one part to another, recommendations for managing multiple accounts, and scenarios in which you can have multiple accounts. Conversations, also called convoys, are an area where different Etsy users

can communicate and build healthy relationships. This is very useful if you want to report lists and different supplier guidelines. Convoys must not be used to send spam, distribute illegal content, or track another account user. A transaction is a section in which Etsy explains its role in transactions and provides all the policies for transactions between buyers and sellers. It also includes the steps that the seller can take if the buyer has not completed the payment and the steps that the buyer can take if the seller does not complete his transaction. If a member of Etsy wishes to provide feedback on the buyer's effectiveness or the seller's goodwill, this section is for you. However, specific recommendations must be followed in the feedback. Marketplace criteria shed light on the type of behavior that is acceptable in terms of sales and is not available on the website. Many Etsy sellers will be interested in using different advertising tactics to promote their products and businesses more, but there are certain specifications that they must follow. These rules are mentioned in the Etsy advertising category. Etsy members can use the tagging feature to warn when the site has potential features, or even flag the behavior of a particular seller or buyer on the site.

CHAPTER FIVE

OPERATING AN ETSY BUSINESS

Finances

Regardless of the type of business, you want to run, one of the most important things that you must understand is your store's financial position. You must keep a record of all the expenses not just to make better decisions, but also to avoid any unpleasant surprises like a huge tax bill or any unforeseen debt.

Regardless of whether you like to use accounting software or like to maintain notes about the same, it is quintessential that you are aware of all the funds that are coming in and are going out of your business. This is the first step of basic bookkeeping, and you will learn more about it in this section.

You need to find a method of bookkeeping that works well for you. If you feel like this is too much work, then it is likely that you will keep procrastinating. You must ensure that you make it a habit to keep track of your business expenses and regularly keep balancing your books of accounts. If most of your supplies come from online purchases, then you can opt for a digitized method of bookkeeping. You must have an exact idea of

the amount you are spending on your necessary business supplies and materials. You need an exact amount since this determines the price of the products you sell.

Here are a couple of online bookkeeping tools that you can use.

Wave is accounting software that provides a variety of features, offers customer support and can be easily integrated with Etsy. Apart from this, this software is available free of cost. All the sales conducted on your Etsy store will be added to the bookkeeping record maintained by Wave. You can also connect it to your PayPal account to keep track of all the payments and receipts. Apart from this, this smart software helps prevent any duplication of transactions.

Wave not only manages your sales, but you can also use it to save customer information, send invoices and even distinguish between your personal and business expenditure. It helps you keep track of the payments you are yet to receive and the sales tax payable. This is a basic software to use and offers all the accounting features you need for bookkeeping including the generation of bank reconciliation statements. Of all the different bookkeeping software available, Wave is among the best ones!

QuickBooks Self-Employed is a comprehensive accounting tool that helps you track your expenses, do the necessary bookkeeping and even offer tax support.

This is the perfect software to a single user in charge of a small business. You can integrate this software with your Etsy store too. As with Wave, you can directly link the sales from your Etsy store to this tool as well. QuickBooks will automatically categorize all your expenses and keep them organized. You can also separate your personal and business transactions. The tax support and assistance offered by this software is perhaps the most brilliant feature! You can calculate all the taxes payable and even estimate your quarterly taxes. If you are looking for a tax assistant, then this is excellent software.

Another bookkeeping platform that you can use is GoDaddy Online Bookkeeping. Even this platform offers complete integration with Etsy, offers excellent tax assistance along with basic bookkeeping features. Like the previous two bookkeeping assistants, even this one will automatically make a note of all your sales on Etsy. There are various accounting options available for Etsy users, but this one offers the best reporting. You can run different reports to see the financial performance of the store, the sales tax payable, the most popular items sold and the status of invoices. All these things come in handy while running your Etsy business.

You can opt for any of the bookkeeping tools mentioned in this section. If you aren't sure what to choose, then the best thing that you can do is perform a trial run on each of these tools and select one that fits all your needs.

Pricing Your Product

When you go through different products listed on Etsy, you will come across certain products that are overpriced and the underpriced ones. It is not just essential to have a great product, but you must also price it optimally if you want to become a successful and profitable Etsy seller. It doesn't make any sense to price a hand knit quilt at $40 and a flimsy owl hat at $13. This is just bad pricing.

A lot of new sellers tend to think that by lowering their prices they can attract more customers. It can be rather tempting to set your prices lower than the ones of your competitor. Regardless of how tempting this might sound, you must not do this. There are a lot of problems you will need to face if you underprice your products. For starters, by underpricing your products you not only stand to incur losses, but you can harm the other sellers too who are pricing their products correctly. While you are setting the prices, there are a couple of different things that you must consider. Since Etsy is a marketplace for handmade items, vintage good and craft supplies, you need to consider the costs you incur for procuring or producing the items, the shipping charges involved, taxes payable and several other overheads. You cannot ignore these items if you want to become a successful seller. In this section, you will learn about all the different things that you must consider while pricing the items for your Etsy store.

The first thing that you must do is make a list of all the materials you need and calculate the expenses involved in procuring the items. For instance, if you are stitching or knitting an item, then the things that you must consider while pricing the final product will include the cost of the yarn, buttons, thread, crochet hooks and so on. Also, you must include all the costs and fees involved like the fees payable to Etsy and PayPal for using their services. If you need a loom or editing software, you must take all these things into account.

You must also consider the time that goes into making the final product. You will be putting in significant time and effort to make a product, so don't forget to include your per hour rate too. You must set a rate that you think is sufficient without going overboard.

If you want to calculate the price you must sell your products for, here is a formula you can use:

Materials + Labor + Expenses + Profit = Wholesale Price

Retail price = Wholesale Price X 2

This is a rather simple and brilliant way to calculate the pricing of your products. You can use this formula as is or tweak it according to your needs. For instance, if you use this formula to calculate the retail value of a relatively small hand knit blanket, you will end up with a retail price of over $200! The cost of materials included for a small blanket is about $20, it takes around 7 hours to knit

a blanket and if the labor cost is $10 per hour, that makes labor cost $70 and the rest of the expenses along with profit come up to $5 and $15 respectively. So, the wholesale price of the blanket is $100, and this means the retail price will be $200. Woah, isn't that too high? Regardless of how wonderfully knit the blanket is, seldom will any buyer want to spend $200 on a blanket! Instead of using this formula, you can tweak it and price the same product using the following formula:

Materials + Labor + Expenses = Retail price.

When you do this, the retail price of the blanket comes down to $95, and this is more ideal.

You must remember that a lower price doesn't always guarantee higher sales. If you aren't sure of this, you can start by pricing your product at $20 and gradually increase the price. If you notice that buyers are willing to purchase the product at $30, then it certainly makes more sense to set the price at $30 instead of settling for $20 per item. You need to be open to a little experimentation to find the sweet spot. You need to set the price such that you not only earn a profit, but even the buyer will be happy to make the purchase. A simple trick that sellers use is that they include the cost of shipping in the total price payable. For instance, if your product is priced at $25 and the cost of shipping is $5, then you can increase your sales by selling your product at $30 instead of mentioning the additional $5 as shipping charges. Often, a lot of buyers become hesitant

about making a purchase when they see that the shipping costs are mentioned separately. It is all about mental tactics to make the buyer feel comfortable making the purchase.

By using the simple tips given in this section, you will be able to decide an ideal price for your products. Remember, regardless of what you might feel like doing, and you need to earn a profit at the end of the day. So, price your products keeping this in mind.

Dealing with Customers

A lot of people seem to think that it is a breeze to become an Etsy seller. Yes, it is not that difficult, but don't lull yourself into believing that it will always be smooth sailing. People seem to think that Etsy customers are happy to pay a higher price for a right quality item. Well, they are on Etsy, so it means that they must be fond of artsy things and might want to pay for it, right? Well, if you believe this, then it is time to step out of that universe. As with any other business, you will have sure good and bad customers to deal with along the way. In this section, you will learn about how you can deal with customers.

Bad Reviewers

These are the ones who seem to pop out of the blue. They are the ones who either failed to ask any questions, or they imagined a different product than the one they ordered for. Regardless of the reason, they are quite upset, and they feel duty-bound to inform the rest of the world about their disappointment.

So, how do you deal with such customers? The one thing that you must not do is lose your patience. You must always keep your cool and stay level headed even when subjected to the customer's angry rant. If you keep coming up with excuses, try to justify yourself or even

point out their faults (even if they are the ones at fault), it will blow up in your face. Take a moment to gather your wits and place yourself in the customer's shoes. Think of this situation: maybe you ordered something that you were incredibly excited about and were eagerly waiting for the delivery. Once you received the delivery and have spent your hard-earned dollars on it, you realize that the product you received isn't something you were expecting.

If you want to work with this customer, then you must understand the reason why they are upset and try to make it better for them. You can do something as simple as contacting them and saying, "Hello, I just read your review, and I am incredibly sorry that you were dissatisfied with the item delivered. If given an opportunity, I would like to make things right for you! Would you like to exchange the item or do you want me to initiate a refund?"

By doing this, you are not accepting that you were at fault and at the same time you aren't making the customer feel like their angst is unjustified. Every customer, even the angriest ones like to be acknowledged. If you do this, you will be able to rectify a bad review. Once you fix the problem and the angry customer is satisfied, you can gently ask them to edit their negative review. This is a simple technique that will ensure that the seller and the purchaser are both happy.

Never satisfied

You will come across some customers who can never be pleased or satisfied. You can send this customer a carefully drafted response, try placating them, try removing their doubts and then they will turn their tables around and crucify you. Well, these sorts of customers are rather tricky to deal with and can even frustrate you. Usually, this sort of customer is the one who will ask you for more options even after you show them all the options available. They are the ones who will ask you to keep changing things. The problem is, they will never be satisfied- regardless of all that you do.

So, how do you deal with such customers? While dealing with these customers, you must remember that the customer has a specific idea in mind and is working with you because your style appeals to them. So, at least during the initial stages, keep your calm and don't get frustrated. If you are dealing in handmade products and come across such a customer, here is what you can do. You can show one design idea to the customer and offer to make one change free of cost. Apart from this, be upfront with the customer and inform them that any changes to be made beyond this will be chargeable.

Discount hunter

There will always be satisfied customers who assume that they are entitled to discounts on everything. Well, dealing with such customers is entirely up to you, and it is a judgment call. If the customer makes a polite request

asking for a discount, you can indulge the customer, provided it doesn't eat too much into your profit margin. Or maybe you can offer a tiny discount to please the customer. However, if the customer is rude and demands a discount, it is a good idea to decline the customer.

Packaging

What happens after spending hours improving your products, setting up your business, and marketing your products at Etsy? It is time to start selling!

Whether you start as an Etsy retailer or work professionally with thousands of customers, branding and packaging your products can take your store to a new level, increase customer love and loyalty, and attract new customers through referrals.

For example, if you have ever opened a brand-new Apple product, you can say that the company thinks a lot about its brand and packaging. The design of the boxes outlines the products carefully, and everything fits perfectly. It is clean, tidy and simple, yet looks stylish and fashionable at the same time.

The way the product is packaged often leaves the buyer with a happy thought that affects how they see this company in the future, how it discusses with others, and what future orders are there. If you make your customers smile even after the sale, they are more likely to spend money with you in the future. "

Etsy is the most creative community for homegrown online vendors. Therefore, it makes sense to take additional measures to satisfy customers in this way.

The way you label and package your product is an easy way to secure future orders and receive satisfactory feedback on your sales. Keep in mind that your feedback is the key to showing others how good your product is and assuring others that they are equally useful when you buy from them.

This is possible without much investment and very important for the customer experience. To impress customers with a great buying experience, you do not need to invest heavily. This can be done with a few simple tricks and hacks for packing and unpacking. In this section, you will learn how to create or update your brand and packaging to satisfy your customers and increase sales.

A simple way to pack your products is by wrapping them in a bag or a bubble wrap before placing them in the shipping container. When you make this little effort of double packing the order, the customers will also be able to see that you take pride in your work. No one likes a shabby package, especially when they are shelling out their hard-earned money on it. You can decorate the package with some stickers, ribbons, stamps or ties. All these small embellishments don't take up much time, but they certainly help to create a good impression. You can start using eco-friendly products for the sake of

packaging. Going eco-friendly seems to be all the rage these days. So, it is time to capitalize the same! You can include small surprises in the package. You can add a badge with your Etsy store's logo on it. This is a great way to brand your store while eliciting a smile from your customer. Not just that, you can even add a small thank you note to the package. These small steps will go a long way when you are trying to develop a healthy and positive relationship with your customers.

Shipping

From estimating shipping costs for your first Etsy listing to wrapping a fragile order, a newbie to shipping can sound like a guessing game: how much should you take? How can you guarantee that your goods arrive safely? How often should you communicate with your customer?

It is normal to be a little worried about the shipping and handling process - in fact; this is one of the most common problems that new sellers are encountering. But as any seasoned salesman would say, this is a process that will become easier with time and practice - and a few ideas. In this section, you will learn about the different things that you must keep in mind while estimating the shipping costs.

Calculate the shipping costs

Regardless of whether you are shipping the whole country or the whole world, knowing the weight and size

of your product is the first step to quickly and accurately calculate shipping costs. The easiest way to determine the weight of your item is to use a scale, such as B. a digital scale or a kitchen scale.

If you do not have access to your scale, you don't have to worry. You can bring your items to the post office and use their free letter scale, average the weight of an item like yours on the internet, or round off the weight of your item compared to regular household items (such as a flour bag).

Since many shipping prices are based on "weight levels," the availability of some consumables is also helpful to get an accurate weight estimate when listing your items. If in doubt, you can add a little extra to your estimation. You can always refund any extra postal charges, but you cannot ask for more if you didn't weigh the package correctly.

Keep your customers up to date

Clear communication with your customer during the ordering process is just as important as the packaging of your goods. First, determine clear expectations of how much time it takes to prepare and place an order during the processing time of your product. Eg, if you take 3 days for personalizing, packaging and shipping the goods, and 3-5 days are required to deliver the freight forwarder, you must inform customers that receiving the goods takes up to 8 working days.

Make sure the rules of your business indicate whether you accept exchanges and returns. If you do, inform them who has to handle the shipping costs and also about the return policy.

If your product is sold, the customer will receive an e-mail containing your message to buyers, if you have written them. After you have sent the order, inform the customer that the goods are in transit. You can do this quickly by going to your store> Orders. Click the "Mark as Sent" button next to the order. A notification will then be sent to the buyer. Whenever possible, it makes sense to provide tracking information so that customers can monitor the progress of their goods and eliminate problems with delivery directly from the carrier. If you are concerned about the extra costs that are sometimes associated with the service, consider tracking, as a delivery update so that customers can pay the extra cost if tracking is a priority.

Pack your order

Once your product is sold, it's time to ship an order safely and securely. In addition to packaging materials such as bubble wrap, adding several other ingredients will make the packaging completer and more professional. Many sellers like to add a packing list and a quick thank you to the buyer. (If you have a business card or other business material that contains the name of your business, you can also add it.)

Although you are probably familiar with the entire packaging process, you must be extra careful when delivering delicate items. You must ensure that the item is packed correctly and has sufficient padding so that it doesn't get damaged during transit.

Taxation

You will not attract any tax liability if you sell your old laptop. However, once you decide to start selling handcrafted items or vintage items on platforms like Etsy, you will need to report your earnings from it and pay the taxes applicable to it. Not just that, you will also be liable to pay self-employment tax on any profits you earn and, in some areas, you might also need to collect sales tax. So, don't forget to check the local taxation policies in the area you reside.

If you are selling items on Etsy, then you need to pay tax on the income you obtain. This is usually calculated by deducting your total overheads and business expenses from the total income derived from sales. Etsy is duty-bound to report your gross earnings to the IRS, so you need to report your sales income from Etsy on your tax returns as well. If there is any income tax levied by the state you reside in, then in such case you are liable to pay state income tax on your net income from your Etsy business.

If you can earn a profit from your Etsy store, then certain business expenses are deductible like the cost of

advertising, the cost of materials and shipping charges. You can deduct these expenses even if you don't make any profits. So, if you do incur a loss from the Etsy store, you can set this loss off against any other taxable income you earn like the income from any other job or business.

If your Etsy store is merely a hobby, then you cannot deduct any losses you incur from such a hobby from your taxable income. So, if you don't want the IRS to treat your Etsy store as a hobby, then you need to maintain detailed and proper business records and ensure that your business earns a profit in at least three out of five years.

You are liable to pay self-employment tax if the income from the Etsy sales is more than $400. Self-employment tax consists of Social security as well as Medicare taxes. These taxes are usually charged and are withheld from the salary that you earn as an employee. Since you are self-employed, you are directly liable to pay for these taxes. When you are self-employed, and your income is less than $200,000 and $250,000 if you are filing taxes jointly, then you must pay the Social Security and the Medicare taxes by yourself. As of 2018, you are liable to pay Social Security tax at the rate of 12.4% on the first $128,000 you earn and 2.9% of your total income is payable as Medicare tax. If your income is higher than the amount mentioned, then you will be liable to pay an additional Medicare tax at the rate of 0.9%. If you consider the sales income from Etsy as a hobby, then

you will be liable to pay other taxes and not self-employment taxes.

The sales tax policy changes from one state to another, and it also depends on the local governments. Usually, a small percentage of each sale you make goes toward sales tax. Usually, the responsibility of collecting the sales tax from the buyer and redirecting it to the concerned authorities falls on the online seller. So, check the local and state laws to learn about the sales tax policy.

Taxes! Regardless of whether you enjoy doing your taxes or loathe it, you cannot avoid it! Taxes don't have to be something that you dread, and you can make things easier for yourself by being a little organized. Now that you are aware of the different taxes you need to pay for your Etsy business, here are a couple of easy ways in which you can stay organized and make tax filing less irksome.

Yes, it might take a lot of your time and energy to run an online store, but you need to set some time aside daily to do a little bookkeeping. It can be quite simple to make a record of your daily transactions and make a note of them instead of waiting until the year-end to make a list of all your transactions. If you want a simple means of keeping track of your business expenses, then you must consider getting a separate debit or credit card for your business. When you do this, all the transactions transacted with your business card will solely be business expenses. This will undoubtedly make things a little

easier for you. Having a list of your business expenses displayed in one place is quite helpful, mainly when you are calculating your tax liability. Regardless of the filing system that you use, you must ensure that you always store all your financial files in one spot. If your files aren't organized, it will become tricky to search for all the related receipts and invoices at the end of the year. You can invest in any of the bookkeeping software that was discussed in the previous sections to make things easier!

CHAPTER SIX

SELLING ON ETSY

Offer custom items

You can always accept requests for individual orders. To let your customers know you're ready to take their ideas into account, you can add the "request a custom item" link on your business page. When a customer clicks on this link, Etsy opens a personal conversation between the buyer and the seller. The link "Request order" can also be displayed on the product list page. To add a custom "Request" link to your homepage, click the "Your Store" link on the Etsy page. On the left side of the page, click the "Options" link under the shop settings. The Store Options page opens in which you need to enable the Request custom item option. Save your changes now. When you return to the main page, the "Request custom item" link appears on the main page of the store. Its not just about accepting requests to customize orders. You can also write about custom lists. Custom collections allow shoppers to request customization of certain aspects of the item they want to buy, as long as the seller can adjust that adjustment. When you are ready to make adjustments, there are distinct possibilities that you can do. You can ask for a

deposit as the item cannot be sold or used for other purposes after the personalization. Setup fees may apply. All items that have the settings available can be marked as personalized, personalized or made to order in the list. You must specify the options that can be entered into the product. You must inform the buyer about the process and rules of the business. You must provide the buyer with a timeframe to let them know when to expect delivery of their product. Before sending the goods, make sure you send a photo of the same buyer.

Timing your Etsy post

To make sure that the listing you want to post on Etsy reaches a broad audience and covers as many of your potential customers as possible, you will need to plan a little. After you've posted your listing, you can always access your account to see it before it expires. If you publish your data to Etsy for a few seconds, it will be displayed on the Etsy homepage under the Recent Items tab. To ensure the maximum number of buyers who can see your publication, you must consider publishing at a specific time. If your target group is mothers on the East Coast, it will be helpful if you post your entry at 9:30 am EST after they've got their kids to bed, or at 12:15 pm local time, when all are in California at lunchtime. Because Etsy is an international organization, there is a possibility that peak times may occur in one place or another, regardless of the publication of an entry. If your schedule is such that you aren't able to create a listing

during the peak time, you don't have to worry. You can create a list in your spare time, and if the time is right, you can publish your list. Do not click on the "Publish" button after creating your entry, but on the "Save as draft" button. When you're ready to publish your data, all you need to do is sign in to your account, open the Lists Theme option, available on the left side of the page, check the box next to the list, and click the Publish button to upload the list. All listings published on Etsy will take 120 days if the product has not been sold or listing is disabled.

You can determine the expiration date of a particular offer by signing in to your Etsy account. Then under the "Subject" option, click the link that is currently for sale. Now locate the list whose expiration date you want to know, and this date will appear in the expiration column next to the list. If there are multiple entries in your Etsy store, you can sort them by expiration date. To do this, you need to click on the Expires column header on the page.

Setting up payment methods on Etsy

There are several payment methods that you can choose for your Etsy shop. However, depending on your convenience and preferences, one or more of these options may be ideal for your Etsy business. You can choose the following payment methods: The credit card is one of the options. During Etsy Direct Payments, he can accept payments with credit cards such as Visa,

MasterCard, American Express and Discover. This is the most popular form of payment on the site, although this feature is only available in the US. The direct order also provides Etsy users with protection that can prevent fraud. You can also buy and print delivery labels from the US Postal Service at your Etsy store. You must pay a 3% processing fee on the total sale, including shipping and sales tax. PayPal is a popular payment method. All electronic payments can be instantly credited to your PayPal account, and you can quickly transfer money from your PayPal account to the bank. If you are an old school, you can choose a simple money transfer. For those who are shy of technology, this is a good option. The disadvantage of this method, however, is that the payment cannot be made immediately. You will have to wait patiently for the transfer by mail. Paying with personal checks also has the same advantages and disadvantages as the transfer. Payment is delayed compared to other instant payment methods. If you wish, you can accept other payment methods, such as Bank checks or other forms of payment that you consider appropriate.

If you have decided on the method of payment that you will like to accept, you must provide it to Etsy. Click on the link your shop at the top of the Etsy page. When this page opens, go to the Paid or Payment in the Business tab if you want to select credit or gift cards as a payment method, select Etsy's Direct Checkout. To enable the Direct Checkout option, you must click the Sign In

button to view the terms of this service. Read the Terms of Service carefully and click "Next" to accept them. Etsy encourages you to provide your personal information such as your name, date of birth, the last four digits of your Social Security number or tax code issued by the Federal Government, your home address, telephone number, and company name. You do not have to worry because this information will not be published. This is for internal use only. After you have entered all this information, you must click on the "Next" button. In the next step, enter your bank details, account type, name of the account holder, bank number and your account number. The final step is to sign up for the option once you have entered all the required information, and Etsy will register you for Direct Checkout. If you want to accept other payment methods, such as: For example, PayPal, money transfers, etc., you must click the "Payment" tab, select the "More payment methods" option, and specify when the list is displayed. You must mark the payment options you want. After that, you have to save the changes. Please ensure that the modes of payment you opt for are globally accepted.

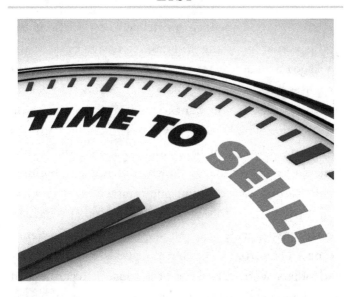

Things to include in your shipping policy

If you do not want to be a salesperson that will knowingly advise your customers how and when they can expect to deliver their goods, you must have a clear delivery policy. When developing your shipping policies, there are a few things to keep in mind.

First of all, you have to select the forwarder you want to use for the delivery. This may be the United States Postal Service, FedEx, DHL, UPS or other options available. After selecting your carrier, you must select a specific delivery option. For example, depending on your needs, you can choose First Class, Priority Mail, or Media Mail. You have to decide if you want to include delivery confirmation or insurance for the delivery. It will be

better to have insurance on delivery, especially if the goods you are working with are expensive because the package is lost during transport; At least you can get your expenses back. You have to decide if you want to deliver internationally. If you want to ship internationally, you must decide whether the buyer has to charge customs fees. This allows you to handle combined shipments. Sellers often offer discounts when buyers buy multiple items in their Etsy store in one transaction. It is up to you if you want to follow this practice. You also have to decide how quickly you can ship the purchased items. Some sellers promise to ship the goods within one day and others who will take a little longer. Regardless of what you specify with the delivery time, you must tell your customers. When you accept orders for custom products, you must also consider the time you spend adjusting them. The buyer may need the goods as soon as possible, and in such a situation you must be prepared to update your delivery method to accommodate these buyers. Finally, you have to decide on the shipping method of your products. You can also offer the possibility of gift-wrapping if possible.

Etsy's Seller Protection Program

Try your best as you like, not every transaction will run smoothly, and you will come across multiple strokes. Fortunately, Etsy offers seller protection. This program ensures that the status of your account remains unchanged, even if the buyer reports a specific issue with

your Etsy store. There are certain things you need to do to participate in the seller protection program. You need to publish all the rules of your store regarding shipping, exchange, return and customization on the rules page of your Etsy store. Try communicating with clients via convoys, rather than email or otherwise. The items on your list must have accurate photos that do not allow for color, size, material, and description distortion. The buyer must have a real sense of what he buys. Use the tools offered by Etsy, give your customers the date of the expected delivery and make sure their delivery arrives on time. Send the goods to the address stated on the Etsy receipt or to another address agreed by the buyer. After you've sent the articles, highlight the same thing with Etsy. If the price of your item exceeds $ 250, you can confirm the signature on delivery using the tracking method. You must provide proof of delivery, and for goods shipped to the US, you must also track the delivery confirmation. Answer all disputes and, within seven days, contact the buyer involved in such an incident. Also, you must also answer any inquiries that Etsy sends. Another benefit of this program is that it provides full coverage for items purchased through the Etsy Direct Checkout Tool for up to $ 1,000. So if a good deal goes south, you will be safe. This program is not available for all products. For example, transactions related to digital goods or articles that are to be delivered electronically are not included.

Things to consider before starting an Etsy shop

Etsy is an excellent platform for start-up entrepreneurs working with arts and crafts, art and vintage products. However, there are a few things to consider before entering the Etsy Seller Pool.

Research: Whether it's an idea you've recently come across, or something you've been doing for some time, you'll need to do enough online research before building your own e-commerce business. Listing on Etsy is not the only criterion; you also need willing buyers for your items. During the study, do you need to find out if there is a demand for the goods you produce? Do you already have similar products on offer, the price at which your competitors sell similar products? If you have not seen such products before, think about the reasons why you did not. Find out if the product you made is viable or not, use your products for the customers and the amount of money you need to calculate them for the product you are offering along with the shipping guidelines. If you can answer these questions, you can continue with your Etsy idea.

Originality: Originality can be understood as a fresh look at an existing object, its design or style. It is very likely that the product you are selling is not the only product available in a particular category, and you probably have competitors. In this situation, you need something that sets you apart from the others. You need to be able to answer specific questions when deciding whether your

product has originality. What are the features that make your product special? Of course, there is some competition. Why must the buyer choose your product compared to your competitor? What do you offer your competitors? What makes your article unique and not similar to others that are already available? If you decide that there is no product like the one you sold, how will you attract the attention of the buyer? Once you've done a lot of research and know that your product has originality, you need to think about your target audience.

Ideal audience: Every company must have a target group. Your target audience is those who are interested in buying what you can offer. If you're not sure who's going to buy your product, you'll probably want to reconsider this problem, because nobody will likely buy your product. If you can determine your target market, you can take steps in the right direction to increase sales and expand your business someday. There are a few simple questions that will help you to determine your target audience. Who do you represent as your clients, their age, gender, occupation, etc.? Why must you buy your product? How do your target customers find you, will they be online, on social networks or do you need to consider other forms of advertising? Do your customers want to repeat the deal?

Time is money: it is true, and no matter how cliché sounds, it always stays true, especially if you have your own business. You need to know how much time you

want to devote to your business at Etsy. If you do not have time to build and manage a business at Etsy, you will not succeed. Successful Etsy stores are maintained in good condition regardless of current sales and updated regularly. You need to spend a lot of time and effort if you want to make it big. You need to be sure that your business is regularly updated, inviting and informative. Your advertising and marketing strategy must be reasonable and help attract the attention of your target audience. You need a well-thought-out delivery policy, a corporate page, and all the information you think your customers need. Your work does not stop after opening a store on Etsy, but you also need to manage the store. This means that you can regularly review the store, answer any questions you receive, change the entries, and respond to sales. Keeping a business at Etsy is like shopping in real life. That's why you have to take care of it regularly. You also need to promote and advertise your store to increase sales in the past. The more creative you are, the more attention you get.

Etsy Style: There are many things people can sell at the local craft fair or at their friends and family - products that work well for Etsy, but for some reason do not work for Etsy. It's not just about researching your product; you also need to familiarize yourself with the Etsy market. Have you ever bought something from Etsy? Look around and understand this market, because Etsy is not eBay and not even a local craft fair. Therefore, you

must ensure that your product is well suited for Etsy. You need to find out if people want to buy your product if you want to choose your product compared to others, what price they want to pay for, and whether you're doing a hobby or are interested in using it as a profession. If you cannot answer these questions to convince yourself, you must probably reconsider the shop set up at Etsy. If you have the answers to all these questions, you can make the most of Etsy, because Etsy is the place for you.

Etsy is a great place to sell your products, but you need to spend a lot of time and effort, and be patient, as the results will produce a positive result.

Tips for Choosing a User Name for Your Etsy Account

The username you choose for Etsy will be yours as long as you have a valid Etsy account. If you decide to open a store at Etsy, your username will be the name of your store. So be careful when choosing a username. Etsy generates two filenames, depending on your username, and you can choose one. If you select a username on Etsy, you need to remember a few hints. Choose a name that is easy to remember, spelled out, and contains no more than one or two words that are synchronized with each other. If you have subscribers elsewhere, you can use your name as your username. This will make it difficult for you to protect your privacy with Etsy, but it will help you to capitalize on your success in the real

world. Imagine a name that reflects what you sell. For example, if you specialize in fridge magnets, you can probably include the word "magnets" in your username. Choose your name carefully so that it can be expanded in the future. For example, suppose you have multiple accounts in Etsy, one for each type of business in which you are involved, and you must disclose other profiles for each of your accounts. Choose a username that suits your style, and for legal reasons, it will be in your best interest to avoid using words that are trademarks or protected by copyright.

For obvious reasons, Etsy prohibits the use of words that are considered racist or offensive. If you want, you can change your username. But you will need to create a new account and then access it. If you are a seller, you will not mind much. However, having an Etsy configuration store and having a follower base can cause a headache. You have to manually move products from one store to another, which means you, have to pay the listing fee again. Another problem with changing your username is that sales materials, customer reviews, conversations, and all other Etsy interactions are not transferred to your new store. Think carefully about what is good for your business and select a username accordingly.

What Are Etsy Forums?

The member forums offered in Etsy allow you to interact with members of the Etsy community. Etsy is a

great place to buy and sell handcrafted and vintage products. But Etsy is much more than just a virtual market. This is an online community of interesting, talented and creative people. The forum is considered a meeting place for the public to hold open discussions. This word comes from the system of trading rooms and public spaces that existed in the Roman Empire. Similarly, Etsy forums offer such a meeting place to all its members. Etsy forums are public forums where members can discuss any topic.

Etsy supports five significant forums. The first is ads; this forum is designed specifically for Etsy employees to serve ads related to the site. Users must continuously review this forum to be aware of any pending changes to the site. The other forum is a website help. As the name suggests, it provides answers to frequently asked questions that users might have regarding Etsy, its primary usage, questions about the features proposed, or any additional requests regarding the site's policies. Anyone who belongs to the Etsy community or Etsy staff will answer the questions in this forum. The third forum deals with business topics, and here you can seek business advice. For example, you may receive information about the administration and marketing of Etsy Shop Help, any PayPal related issues, delivery issues, or business process advice. You may come up with the idea that can revolutionize Etsy. In such cases, there is an Etsy forum for sharing your ideas. You can also use Idea to discuss changes to the website or

another website with constructive criticism. The Bugs Forum is intended to report any bugs that have occurred on the site to check if other users have encountered similar errors. You can use this forum to report such errors. No Etsy forum is a complaints department. If you have complaints, you can send them to community@etsy.com.

How to join or start an Etsy chat room

Etsy supports various chat rooms that allow you to interact with other Etsy members. For example, you can join the chat organized by the captain of your favorite Etsy team. If no chat meets your specific needs, you can always create a new chat.

To access other Etsy chat users, you need to open the Etsy Community homepage. Now click on the chat link at the top center of the page. When chat pages are opened, a list of currently active chat rooms is displayed. You can also create a new chat room according to your needs. If you'd like to join an already-enabled chat room, click the Join button on the Chat room's page next to the entry in the chat room you'd like to enter. If the chat you want to join has a password, and you see a box with the lock option to join the chat, you will need to enter a password and enter the chat.

Every Etsy chat has the same layout, regardless of whether it's new or already existing. On the left side of the screen, you will see lines of text that scroll upwards.

These lines of text are a conversation that takes place in the chat and the corresponding name of the user who typed it. To add your own opinions to the chat, you must enter the chat box and press Enter or Send. On the right side of the chat are pictures. These are the pictures that have been published in chat regarding different lists, as well as links to these lists. The smaller picture shows the avatar of the user who released the list. If you want to share your item or list, you can copy the ID or URL of the list and paste it into the box below the scrollable images. Then click on Send or Enter. You can share photos from any list, not just your own. The thumbnails that appear under all item lists are avatars of Etsy users who are in the current chat. If you mouse over the image, links to Etsy Shop, profile and message will be displayed.

Creating a new chat room is as easy as joining a new chat room. At the bottom of the Chat Rooms page, all you have to do is enter the name of the chat room you want to create in the "Create a New Room" section. You can either create a password to keep it private. Enter the password to protect the chat in the Password field. You can send the same password to other Etsy users through your account. Now you need to click the Create option to create the chat room you want. You cannot close the chat room that you have opened, but it will be hidden from the active chat list if it is idle for a while.

CHAPTER SEVEN

MARKETING STRATEGIES

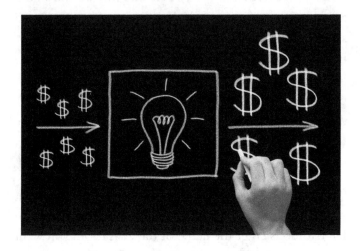

Marketing on Etsy is quite important, and if you want to attain the kind of success that you have been dreaming of, then you must use different marketing strategies. At times sellers tend to take a couple of years before they finally figure out the marketing strategies that will work for them. Well, this is one thing that you don't have to worry about because in this section you will learn about various marketing strategies you can use to make your Etsy store a huge success. Before you start learning

about the different marketing strategies you can use, there are two things that you must never forget.

The first thing is that people might need to repeatedly come in contact with either you or your product listings before they decide to make a purchase. Did you ever go through an online store and notice something that caught your attention? Even though it is something that you liked, you don't always make a purchase. However, when the same item keeps popping up in Google Adsense or any of your social media networks, then your desire to buy that product will increase. Likewise, your target customers also need to come in contact with you or your Etsy store a couple of times before they are ready to make the purchase.

The second thing is that viewers are probably not seeing the products listed on your store as often as you seem to think. Most people don't usually have the time to mindlessly browse through tens of thousands of pages on the Internet to find your product. If you want to increase your sales, then you must ensure that the online visibility of your Etsy store increases. To do this, you need to apply specific marketing tactics, and you will learn about all this in this section.

Brand Ambassadors

A lot of newcomers might find this rather tricky, and a lot of people aren't sure of how to go about it. Well, using brand ambassadors is quite similar to hiring a

publicity firm for the sake of advertising but without burning a hole in your pocket. Brand ambassadors refer to people who agree to promote your products on different social networking platforms in exchange for free product samples. Brand enthusiasts also work along the same lines; the only difference is that you don't have to send any free products to brand enthusiasts. To a brand enthusiast, you might need to offer a discount or promotional offer like 50% off, set a minimum purchase requirement for a couple of months and have all those individuals promote your brand as brand ambassadors do. If you want to collaborate with brand ambassadors, then you need to identify influencers in your related niche or industry on social media and get them on board. Either brand ambassadors or brand enthusiasts are an excellent marketing strategy that can help introduce your brand to a broader audience, and the effort that you need to make in this regard is quite simple and straightforward.

So, how do you find such individuals? The simplest way to go about doing this is by starting a shout-out on your social media profiles. The people that follow you or your store might already be fond of your products and offering free products is a great idea.

Product Roundup

Do you want to introduce your products to a broad audience? The marketing strategy discussed here is rather brilliant because of its effectiveness and ease.

Here is how you go about creating a product roundup. The first thing that you must do is select one to three products from your listing that you want to market. Then you need to create a theme that you want to focus on. A quick search on Etsy will help you find products that will match your theme and will be complementary to it. Now, you must make a list of 10-13 items and place them in a document (each item must be numbered). Ensure that the image you are creating can be effectively used on Pinterest as well as Instagram. List the corresponding numbers of the products in any of your next social media posts and include a direct link to the store that product is from. You need to send the graphic you created along with the link to all the shops you included in the roundup and ask the other shop owners to promote the same.

You can directly mail or message the same to all the other interested parties with a message asking them to promote the image or graphic. Are you wondering why others might get on board with this idea? Well, you have included the direct links to the stores selling other items too, and if the other sellers decide to promote their products, they will indirectly be promoting your items as well.

Mingle with Your Audience

Ensure that you regularly keep checking different Etsy forums to see any recent developments. Once you start regularly visiting these chat rooms, you will soon

recognize some people who are regular users, and you can start talking to them. If you are there to socialize, it is all good. However, if your sole intention is to gain more views and increase your sales, then you will end up wasting your time. Take a moment and think about where you think you can find your target audience? Is there a particular magazine that they read? Are they active on any online forums? What is their preferred social networking platform? Are you not sure where to find your target audience? How do you rectify this situation? Well, you can ask them!

You can start connecting with other shop owners on the Etsy platforms to develop business connections, but if you want to increase your sales, then Etsy forums aren't the right place to head to. Your primary intention must be to seem like a helpful resource and an expert in your niche. Does all this seem tricky to understand? For instance, if you are selling contemporary jewelry pieces, then it is a good idea to start commenting on the posts of other style-bloggers or join any fashion magazine forums. While doing all this, you must ensure that you don't include any spam and are offering sound advice and solutions to the discussions going on. Not just that, when you do this, you can slyly include the link to your store in such discussions. So, this is how you go about doing this- you must provide valuable information on at least three instances before you go ahead and ask them to visit your store.

Press Matters

The idea of hiring a professional PR team might sound rather dreamy and pleasant, but this isn't always an option for newbies of Etsy. So, what can you do to get your product photos or information about your Etsy store in the media? You must try to find your press to help you achieve this. For instance, different services like Launch Grow Joy Media Leads will keep sending you emails and regular updates about the kind of products that media outlets are looking for and will also put you in touch with those editors. You will mostly be pitching a product to editors who are already interested in the kind of products you deal in. This is quite wonderful and helps you establish good business relations with editors of different media tools. On the downside, such services usually have a monthly fee that goes along with them. However, the fees charged by such online services are not as steep as the one charged by PR firms.

Newsletters

Social media is undoubtedly a great way to increase the awareness about your Etsy store and the products you offer. However, there is one major drawback; you never have absolute control over them. For instance, Instagram changed its algorithm earlier this year, and this changed the way the Instagram feed works. Regardless of whether you like it or not, there isn't a thing that you can do about it.

This is one of the reasons why email marketing is still considered to be a useful tool. If you have a mailing list, then your work is cut out for you. If you don't have a mailing list, then it is time to change this situation. A mailing list might sound rather old-fashioned, but it is still as effective as it was in the past. You can start using an email service provider like CovertKit or MailChimp for sending out newsletters. Once you have an email list in place, you can start by sending out two newsletters every month to ensure that your potential customers and existing customers stay interested. You can include information about any new products being added to the list, any behind the scenes information or anything about upcoming events. You must ensure that your newsletter offers something of value to the reader. If the newsletter fails to do this and is full of promotional fluff, the reader will quickly lose interest, and your idea of marketing will not be effective. If you want the reader not just to read the newsletter but take some action instead of ending up in the spam folder, you must offer something of value to the readers.

Freebies

Who doesn't like freebies? You can start creating freebies for your fans and loyal customers. You can ask a customer for their email address and offer them a freebie in return. You might think that as an Etsy seller, your aim is only to sell products. Well, this is true, at least superficially. However, if you want to stand apart from

all the other sellers on the platform and you do want your business to grow, then it is time to start creating a brand that offers value to its customers.

The freebie you decide to offer must reflect the same. You don't need to splurge on creating these freebies. It can be something as simple as a printable checklist, a downloadable file or even a DIY video. While doing this, please keep in mind that you aren't offering random content and whatever you make an offer will be valuable to your customers. The idea is to hold onto your existing customers while attracting new ones. For instance, if you sell handmade baby blankets, then you can offer a downloadable and printable checklist of essential items for a nursery or even a step-by-step video tutorial about designing the perfect nursery as a freebie.

Contests and Giveaways

Hosting contests and giveaways have become rather common on social networking sites these days. Their popularity is justified- this is a somewhat effective method of marketing your brand and increasing your brand awareness on the market. While hosting a giveaway or a contest, there are a couple of things that you must keep in mind. The first thing is that you need to make it easy for participants to enter the contest. If you make writing a 500-word essay the criterion to enter the contest, you might not succeed. Instead, you can ask people to tag their friend in a post or repost any of your posts to enter the contest. If you notice good response

but not like the one that you were expecting, then it is time to up the ante. You can add a bigger prize, change the prize or even include a couple of runner-up prizes to create a massive buzz about the contest or giveaway. You will need to keep promoting the contest more than once and keep at it until you get the response you want.

Use only the platforms your business needs.

Just because you want to use social networking as part of your social networking strategy does not mean that you choose to include every available platform. Take a moment and think about all available social networks. You should not only master marketing concepts on any of these platforms, but also be an expert in using these channels. Well, it's not possible for a person to start and manage a marketing campaign on all of these platforms. Even an experienced marketer cannot do it all at once. Therefore, you must carefully consider the pros and cons of each of these platforms according to your marketing goals. Another thing that you need to consider is your target audience. You only need to use the platforms where your audience is active. It makes no sense to invest a large portion of your resources in developing an excellent campaign for a particular platform, to understand that your target audience is not using it. For example, if you find that your audience is active on Facebook and YouTube, it does not make sense to develop marketing campaigns for Twitter and Instagram.

Evaluate

If you want to see if your efforts are paying off, you have to do one thing: evaluate all available data. There is only one way to determine if your efforts are working effectively and to evaluate all the data. Some social networking platforms have built-in tools to help you do that. In addition to the built-in tools, there are many third-party options for analysis tools. You can use all the available data and determine the content that answers most, the degree of audience participation in a particular video, the ideal time to publish, etc. Make sure you use the various marketing tools, previously described in this book. These tools will help you analyze and close any gaps in your marketing campaign.

Timing Matters

It's not just about what you post, which influences the number of views received and the degree of engagement. Be sure to rate your posts if you want to increase their reach. Most B2B companies tend to stick to publishing only during regular business hours, but even in this case, you have a few days when you get a better answer than the others. Therefore, you must do your homework and plan your contributions when most of your audience is active. For example, if your audience is made up of people between the ages of 25 and 35, most of them can work between 9 and 5 per day, and it makes no sense to post content during the workday.

Connect

One common mistake that many social networking marketers make is to talk to the audience, not them. You should try to start a dialogue with them instead of a monologue. You need to communicate with your subscribers, interact with and interact with your audience. If you want to promote your brand on the market, you must succeed in creating an influential audience. You need to make your followers feel they are interacting with a person, not an automatic bot. You can start a conversation by asking your subscribers their opinion, their thoughts, or merely responding to their comments. If you ignore their comments or do not respond in time, they will feel that they are not appreciated and that you are not interested in interacting.

Unique

Several tools allow you to share content across platforms. It's a good idea to share content across multiple platforms. However, you must make sure that you do not use the same content everywhere. You can reuse the shared content at any time, but you cannot use the same content. For example, if you write something on your blog, you can change its purpose, create a video, and publish it to YouTube. You should avoid placing identical content on different platforms. It's important to remember that a user following you on one network is likely to be tracking you on another network. So, if a user sees identical content everywhere, they'll probably

reject your account. By making each of your accounts unique, you can attract more people and attract more followers and potential customers.

Of course, you can be more relaxed when advertising on social networks. However, this does not mean that you do not stay professional. You need to find a balance to make your brand or business more professional and more relaxed. You need to make sure that viewers feel they are interacting with a person rather than being rude. So, try to attract your audience with casual banter.

Don't Oversell

It may seem strange that one of the principles of social media marketing is that you should not continue to sell. Yes, you are in social networks to sell. However, this does not mean that you continue to give promotional material. If you do, you will surely lose your followers. You need to make sure the content you're offering to the audience is the right mix of the ad and non-ad content. Ideally, the ratio of non-promotional content to ad spend is 80:20. You need to make it clear to your audience that it will receive valuable content by following you, not just advertising. If you meet something on social networks that you think will please your friends, what will you do? You will share this treat with them. If you find content that you think you like, you're welcome to share it. Share it if the content wasn't created by your competitors.

Tips for Promoting your Etsy Store

Starting a referral program is a good idea since it helps to increase your sales as well as the visibility of your online store. You can set up a referral program by using affiliate marketing. You will necessarily need to pay the affiliates only when they help you complete a sale successfully.

Etsy is a wonderful platform for selling handcrafted items, but it is quintessential that you come up with exciting and unique product designs to attract your target audience. After all, if you keep doing the same thing over and over again, it is quite unlikely that you will be able to stand out from the rest.

Setting up your business on Etsy is a good idea, but you still need a couple of favorable reviews and testimonials to get started. Well, all that you need to do is get your family or close friends to vouch for you! Yes, it can be something as simple as that.

You need to start using social media if you want to promote your Etsy store online. It is quite fortunate that in today's world you can connect with a global audience from the comfort of your living room. You can join any of the popular social networking platforms like Twitter, Facebook or Instagram and gain immediate access to millions of users across the globe. You can create a Facebook page for your business and use it to post regular updates about your store and engage with your target audience.

You can also create an online store on Instagram, and this has become rather popular these days. Once you do this, you can effectively and efficiently drive the traffic from your Instagram handle to your Etsy store.

You can start using Pinterest for sharing your products and ideas with a large online community of interested and potential buyers. Since you will mainly be selling handmade items, vintage products, and craft supplies, Pinterest is a wonderful platform to use.

Nothing drives sales as urgency does. You can create an increase in demand by offering discounts and limited time offers. You can offer a discount coupon that allows the buyer to claim a discount, provided the sale is made within a specific time. You can use this technique around holiday seasons to increase your sales.

If you want to improve your sales quickly, then you can start collaborating with other sellers on Etsy. You can look for different sellers who have a similar target audience as yours and then combine forces to increase your combined sales. You can also conduct collaborative contests!

It is quite easy to motivate other brands to promote you. You can do this if you have a significant number of followers and you can ask others to promote your Etsy store while you return the favor.

One of the simplest ways in which you can improve the awareness about your Etsy store is by asking a popular

blogger in your niche to feature your store. You need to get in touch with famous bloggers in your chosen niche or industry, reach out to them and ask them to review any of your products. If they are interested, then you can send them your products and get their testimonials in return. Not just bloggers, you can also ask vloggers to review your products. This is a great way to lend a human feel to your Etsy business.

SEO or Search Engine Optimization is another essential tool that you cannot overlook. Why is SEO important for your Etsy store? Well, most of the web traffic to your store comes from the results generated by search engines. For instance, whenever you search for something on a search engine like Google, it will display the appropriate results. Every search generates tens of thousands of results. The results that are optimized for search engines will be among the top results displayed. To do this, you must ensure that you are using the right keywords and are using them aptly. Whenever a search engine displays the results, do you click on the first link displayed or do you browse through all the thousands of results displayed? Likewise, even the potential buyers of your products will look for the top results. So, it is time to make your Etsy store optimized for search engines.

When it comes to promoting and marketing your business, there are various ideas to choose from, and this is the time to let your creativity take over. You can start using any of the tips discussed in this chapter in your

marketing strategy. Now, all that's left for you to do is get started.

CONCLUSION

I want to thank you once again for choosing this book. I hope it proved to be an informative and enjoyable read!

This book is a helpful guide for existing as well as potential Etsy sellers. It will help you understand the fundamentals of running and maintaining a profitable business on Etsy and become a small business owner. All the chapters in this book are divided into simple topics that make it easier to understand the different intricacies of Etsy so that you can make the most of it. In this book, you were given information about the fundamentals of starting a business, marketing strategies, tips for getting started, mistakes to avoid, about bookkeeping, business plans and everything else in between. Once you are armed with all this knowledge, you will be able to make informed decisions and steer your business towards success.

Now, all that's left for you to do is get started! Remember that it takes consistent effort, time and a little patience to get your business up and running. If you work diligently and make smart business decisions, then success is just a stone's throw away!

All the best!

ETSY

MARKETING

Selling on Etsy with SEO, Facebook, Pinterest, Instagram, and Other Social Medias

By Christopher Kent

losses, direct or indirect, which are incurred as a result of the use of information contained within this document, including, but not limited to, —errors, omissions, or inaccuracies.

INTRODUCTION

Due to the ease and convenience of online shopping, a lot of businesses are rapidly revamping themselves and trying to have an online presence. Similarly, a lot of individuals are entering into the world of buying and selling online. There are many websites and web services that allow sellers to sell their merchandise, but Etsy stands out as a unique and 'different' platform among all these services.

If you are not familiar with Etsy and how it works, this book will help you become an excellent Etsy seller and show you different methods that you can use to make your business successful. It contains many tips and tricks that are quite easy to follow, which will help you establish a stronghold as an Etsy seller.

Remember, launching your product on Etsy can be easy, but becoming popular as a seller will take a lot of effort and dedication. You need to be patient and work hard if you want to become successful.

If you are willing to learn more before you venture as a seller on Etsy, let us get started.

CHAPTER ONE

HOW TO MAKE AN ETSY BUSINESS PROFITABLE

Here are a few things you need to keep in mind when you become successful as an Etsy seller.

Finding the Right Product

Finding the right product to sell on Etsy can be as challenging as selling and marketing it. It does not matter what the nature of your business is. It can be a new store where you plan to sell your craft items, or it can be an old store where you are trying to add new items to the collection, you still need to think carefully and critically before making any solid decisions.

If you have a product in your mind and are confused about it, then these questions below can help you make a decision quickly.

Can you make it?

This is a straightforward question that rarely gets a straightforward answer. Many people tend to start a craft and homemade product business without even making the product. While dreaming is a great way to make new plans, mere dreaming will not help you fulfill them. So if you have never melted wax in your life, it is probably not the best idea to start a store specializing in candles right now.

If you do plan to make the items that you want to sell, it is highly recommended to make samples of the product before listing them on Etsy. It will help in many ways. For instance, it will allow you to solve all the problems and errors present in the product. It will also help you streamline and master the procedure so that you will make perfect products every time. If you do not follow these instructions, you will end up fixing your products right on the verge of delivery. The other advantage is that this will give you an idea of the approximate time that it takes to create a product.

Do you enjoy making it?

This is another fairly obvious question. You cannot run a business dealing with handmade products if you do not like making the products. Many people decide to sell an item because the profit margin is great and not because they enjoy making it. But if you hate making something, you will find the whole process excessively cumbersome and egregious once the orders start to roll in. This may

affect the quality of the product and, ultimately, your attitude toward your business as well.

Can you find an affordable supplier for the raw materials?

A business can't work on a one-time investment. If you need to make products frequently, you need an affordable and sustainable source of raw materials. You want low prices and great products. To achieve this, it is necessary to find a good and reliable supplier so that you can make and sell your products with ease.

Instead of buying your supplies from regular stores, check the wholesale market. You can also import products from other nations in bulk.

Can you expand?

A business that deals with handmade products of one type can become quite boring after a while. But you can keep things exciting by keeping your products fresh. If your product can incorporate design variations and different materials, it will make things more exciting for both the customers and you. Variations can be of many types, including shape, size, colors, use, etc.

Do not add a lot of variety in the initial stages of the business, as this may confuse you and your customers. Add them slowly once you get comfortable with your business.

Does it serve a purpose?

A customer will not purchase something if the product does not fulfill some need or serve a purpose. If the purpose is specific, then a lot of customers will buy it. But this does not mean that people won't buy art products. Art products, too, serve a purpose, the purpose of making the world more beautiful. But, people would rather buy something that serves a more concrete purpose. In the initial stages of your business, it is recommended to go for more practical products.

If you cannot think of any reason why a customer would want to buy your product, try to think of your target audience. For instance, if you are trying to sell book cozies, your targeted customer base will include readers of all ages who like to protect their books. By using this method, you will be able to find a purpose for your product. If the purpose doesn't seem too prominent, change the product.

Are the market conditions favorable?

Do not start a business without performing ample market research if you decide a product, conduct market research to check whether people are looking for this product or not. You can use various means for this, including the Etsy search bar, EtsyRank, the Keywords Everywhere Chrome extension, and Google Keyword Planner. It will help you form a rough idea of how many

people are looking for your item. It will also help to gauge your competition.

You should always select a product that is popular, but not too popular. This means that it should be popular, but not a lot of other sellers should already be selling it. If you still choose a saturated product, try to make your marketing and product as different as possible.

Can you legally sell it?

The legality of the product that you are trying to sell is important. You cannot sell products related to other products or licensed items, characters, logos of brands, teams, etc.

Similarly, certain products need special attention; for instance, products made for children or cosmetics. If you plan to sell these, check the rules first as safety matters.

How will you ship it?

You need to ship your products while selling on Etsy. Weigh your products immediately. You should have an idea of the cost of shipping the product.

Along with the weight of the product, you also need to check out the packing supplies that you will need. You need boxes, tapes, paper, bubble wrap, etc. Check

whether your customers will be willing to pay for shipping.

If your product is too large or too heavy, your customers may or may not be willing to pay for shipping.

If you also plan to sell your products at a craft show, you need to consider how to carry them to the show. If your products can fit into bags that you can carry with you with ease, then it's great, or else you may have to use a rented vehicle.

What is your price point?

Once you have decided on the product, you need to decide the price of the product. To do this, you need to do certain calculations. For instance, you need to check how much a product costs, how much time it requires to make it, how much energy did you put into it, etc. These questions will help you decide the retail price of the product. Once you decide on a price, move on to the next step.

Do some market research. You do not want to try to undercut other sellers, as it will prove to be fatal in the long term. Your price range needs to fit within the current price range, or else potential customers will not flock to your stores fearing that your products are inferior.

If your items cost $30 to make, but almost everyone is selling the same product for $10, then you need to sit down and think. Either you will have to find a way to justify the price to the customers, or you will have to find more cost-effective ingredients.

How will you market it?

Once you have decided on the product and the retail price of the product, you need to come up with a marketing strategy. Generally, people tend to use email lists on Etsy. Others also use social media to popularize their products.

Whichever method you choose, you also need to put some time toward the designing aspect of the listing. You need to check how you plan to photograph your products etc. Making your product look attractive is important.

You will find more about marketing in the later chapters.

It is true that deciding what to sell on Etsy can be quite confusing, but if you think and plan everything properly, you will be able to come up with a profitable and sustainable business in no time.

Branding

An Etsy shop needs to look chic and noticeable so that it can attract return customers all the time. This is where branding comes into play.

Once upon a time, branding meant burning a sign into the buttocks of bulls. This was done so that people would know whose animal it was. The concept remains the same now, except it is not as violent anymore. Branding is now seen in almost every field. It can be applied to everything and everyone.

Gone are the days when brands and branding were only related to PR people and corporate offices. Now everyone has a brand, and if you understand how to use

it and promote it, you will be able to run a successful business in no time.

What Is a Brand?

The brand is much more than a logo or a tagline. A brand is a perception and an expectation. Branding deals with the communication and crafting of that perception. All the things associated with brandings such as logos, jingles, ads, taglines, mascots, etc. are all just means of making the perception perceivable.

A lot of celebrities have become brands. For instance, the names of Ariana Grande, Lady Gaga, Kim Kardashian, Martha Stewart, etc. all bring specific perspectives about the individuals to your mind, respectively. This is because they own a brand of their own, or better yet, they have become a brand themselves.

Similarly, many companies such as Apple, Google, Facebook, etc. have become brands. This means that people know what to expect from these companies and where they stand on certain issues.

If you want to succeed, you need to develop a brand. This way, you can let people know things about you, such as what you care about, what you like, what you dislike, and ultimately why people should care about your products. The stronger the brand, the better the response of the customers will be. A strong brand will

not only help you keep your old customers, but it will also help you invite new ones.

Defining Your Brand

Defining a brand is much more than just choosing a logo, tagline, or name for your shop. Similarly, it is more than choosing your avatar, the fonts, or the colors of your page. Everything that you decide needs to 'go' with your essence. Your every choice should represent your brand's essence.

To check the essence of the 'vibe' of your brand, use these four questions.

1. Why do you make your items?

Your story of making the products should fit in well with the image of your brand. Your authenticity and your personal touch matter a lot in businesses such as Etsy. If you have an interesting story behind the conception of your products, it will attract a lot of customers because they will understand that what they are buying is special and unique.

2. How is your product different?

You need to understand the USP or the Unique Selling Point (Proposition) of your product. Your USP allows you to tell people everything about your product in a line or two. They will know what to expect from you or your

product. For instance, if you make hats, think what makes your hats different than everyone else's hats. Don't think from a seller's point of view, think from the customer's viewpoint. Customers love unique things.

3. Which words do you use to describe your items?

You need to check what kind of words you will use to describe your product or service. For instance, if you sell hats, you need to come up with adjectives that define your product and make them seem unique. You can use the 20-10-4 method to come up with these words. Think of 20 words that describe your brand or product. Then sort them down to 10. And finally, reduce them to 4. This way, you will come up with unique and excellent words. Remember "spiritual, soulful, accessible, and playful" sound and appeal people differently as compared to "sophisticated, elegant, experienced, and chic."

4. Who are your customers?

Not everyone is going to like your product, and you should not try to cater to everyone either. This is a trap that will lead to unfortunate consequences. Think about your customer base, i.e., the people who are most likely to buy your products. Think about their age, the demographics, the kind of content they like, their financial condition, their residence, etc. For instance, if your products target college students, you cannot sell

them for too steep a price. Always keep your prospective customers in mind whenever you make a decision.

If you make Goth jewelry and brand it with bold pastels and an overall cheerful aura, no one will buy your products.

Building Your Brand

Once you define the attributes, the values, and the essence of your brand, you can move on to the next step. You need to build a brand message, i.e., what it stands for. To do this, here is a seven-step formula.

Clarity

You need to deliver your message in a bold and clear way. It will help you stand out, and people will remember you. Do not try to do a lot of things for a lot of people; keep it simple and elegant.

Consistency and Cohesiveness

Your brand needs to be consistent and cohesive across all the platforms that you are planning to market your product. So, for instance, if your Etsy store is Goth-like and dark, your emails, business cards, and flyers cannot be elegant and chic.

Communication

You need to communicate your brand through all the things associated with the product. For instance, your shipping and packaging material should bring out your brand. Your fonts, logo, name, and colors should align with your brand and its 'vibe.'

Competition

If you want your brand to succeed, you need to pay close attention to your competition. You need to put your brand in a competitive atmosphere if you want it to become iconic. Positioning your brand means shaping its image in the minds of your potential customer base.

First, understand what things come to the minds of customers when they think about the category of the product that you want to sell. Do they already own it? Are there any problems associated with the product that you can solve? Can you make their lives easier? Is there some sort of gap that you can fill? Can your product meet the needs that are not being met by other brands and their products?

Customers

You need to build relationships with your customers if you want your business to be sustainable. Building relationships with your customers will help you build your business as well. Know your customers - what they like or do not like, what they need, what they want, etc. Let them know that you can deliver whatever they want.

It is necessary to encourage feedback through your Etsy shop and your social media accounts. Kindness will always bring new and honest customers.

Capture Attention

Being direct, bold, helpful, and authentic can help you capture the attention of your potential customer base. Similarly, being shocking, exciting, surprising, and funny can help you too. Be whatever you can be, but remember to be memorable at all times!

SEO Optimization

Etsy-SEO

SEO or search engine optimization is essential if you want to run a successful online business. Opening an Etsy store does not take a lot of time; in fact, you can create it within a few clicks. But just opening a store does

not mean that you will start reaping in cash in a day or two.

Your sale depends on whether your targeted customer base can find your products or not. This is why Etsy SEO is so important. Focusing on the optimization of your Etsy listing is essential, as it will help you make your product become more visible. A lot of views and visitors mean a lot of sales.

Optimizing products on Etsy is not a difficult task. In this section, let us have a brief look at how to optimize your products. It will help your products reach their target customers.

1. Put the Category in Your Title

It is necessary to include your category in the title. Customers are more likely to search the categories while looking for a particular product. For instance, if the customer is trying to buy herbal soaps, you need to put your products in the category of soaps. Do not call your product something random such as 'Herbs Wash' etc. It won't come up if customers search for herbal soaps. Instead, call it 'Herbal Wash Herbal Soap,' this way, it will show up when the customers search for it.

2. Use Long-Tail Keywords in Titles

It is true that a shorter keyword can bring in a lot of traffic, but it is not a good thing all the time. It may bring

more visitors, but it may or may not bring more buyers. To attract more buyers, you need to use longtail keywords that are more specific.

Short keywords generally bring in people who are just browsing or 'window shopping.' They do not know what to buy, and most of them are just trying to pass their time. Along with this, a lot of sellers use short keywords, which means that your potential customers will get bombarded with products, and they will have to sift and sort through a lot of products to get to yours. Meanwhile, they may find another product they like, therefore increasing your sales.

People who search for longtail keywords are generally on a lookout for specific products and genuinely want to buy them. Longtail keywords reduce competition for you.

To continue with the previous example, let's say the 'customer' searches for 'soap.' He or she will be bombarded with a lot of items that he or she will have to comb through. He or she may or may not buy your product. But if you use a longtail keyword such as 'marjoram herbal soap,' it will bring fewer results. This means that the potential customer will check out your product and may even buy it. Ultimately, it all boils down to understanding and using your niche.

3. Put the Primary Keyword in the Title First

According to research, approximately the first 30 characters of your product title are the most crucial as far as SEO is concerned. This means that the first word of your title needs to be your keyword. Do not put anything random such as color, size, shape, etc. in this prime spot.

4. Include Synonyms

Many times people use different words to look for a product. To avoid losing these potential customers, you need to use some synonyms for your products as well. Put your primary keywords in the title first, but do not forget to add synonyms for the product. For instance, if you are trying to sell soaps, do add words such as 'body washes,' 'scrub,' etc. in the name. You can also include these words in the tags or product descriptions.

5. Vary Keywords for Similar Products

Etsy generally does 'declumping' to give everyone a fair chance. This means that if you sell more than one kind of soap and a customer searches for soaps, he or she will only see one (or two) items by you in the results.

This is why you should not use the same primary keyword for all your products. If you do, you will start to compete with yourself. All your products should show up in the results. To do this, try to use different variations of the keywords for similar products.

6. Don't Be Too Creative with Titles

If you are on Etsy, you are creative and unique. Many sellers try to extend their creativity to their product names as well. While it is a great way to show your uniqueness and creativity, it may have a negative effect on your sales. A creative and unique name is interesting, but it is ineffective from the point of view of the sale. People who are trying to look for products will not use unique keywords to search for them. If you plan to sell your artwork on Etsy, do not use the 'title' of the artwork as the 'title' of your listing. Instead, use the medium of the painting, such as 'acrylic on canvas,' 'oil on canvas,' etc. You can put the 'title' of the artwork in the description of the listing.

7. Use Keywords in Tags

You can use 13 tags to tag your items. This is a great opportunity for you to attract customers. Each tag has a limit of 20 characters. Think as many search terms as you can to make your endeavor profitable. If you plan to sell watches, use keywords such as timepieces, wristwatch, men's watch, antique watch, metal watch, 1925 silver watch, engraved watch, gift watch, etc.

Etsy does not allow you to repeat attributes and categories because they are already used in the search results, so keep your tags as specific as possible.

Using Social Media

Social media promotions can be confusing if you are a beginner. This section will help you decide which social media to focus on to make your shop pop.

Marketing Social Media

Social media is a great and cost-effective tool for promotions, especially for small business owners. With the help of social media marketing, a seller can not only connect with his or her customers, but he or she can also build brand awareness and can meet new potential customers as well.

All forms of social media channels come with their pros and cons. This is why you need to change your promotion style according to the channel. Before you begin a social media promotion campaign, you need to check what kind of strategies work on the platform that you plan to use.

Here is a small list of things that you should keep in mind.

Facebook

- **Pros**

It is great for video content, especially the "Live" feature. It can also be used for customer service, photo

collections, FB messaging, direct contact with customers, connecting with people, sharing product listings, and reaching out to a variety of audiences.

- **Cons**

Not great for reaching out to teens and other young demographics.

Instagram

- **Pros**

Instagram is great for cross-promotion, visually bold appeal, finding and attracting influences, behind-the-scene action, giveaways, IG Stories, reaching young demographics, etc.

- **Cons**

Instagram is not the best platform for overtly promotional content.

Pinterest

- **Pros**

Pinterest is home to on-trend products, trend lovers, inspirational boards, creative thinking, visual thinkers, etc.

- **Cons**

Pinterest can be too time-consuming.

If you are a newbie to the world of social media, it is recommended to promote your shop through only one channel in the beginning. It will keep you from being overwhelmed. You can begin with a channel that suits your current needs and the one that you can handle with ease. If you are a social media nut, you can begin your promotions through all the channels all at once. Use the power of social media to its full extent to reap the benefits fully.

Facebook for Connecting with Customers

One of the best sites to connect with your potential buyers who are already familiar with your products and brands is Facebook. There are many different tools available on Facebook that can help you promote your brand. For instance, the "Live" option can help you connect with your customers directly. It can also help let them know what new developments are going on with your shop.

Facebook can also be used to share information about new products and give customers sneak peeks of your new products. You can use Facebook to gain feedback from your customers. It can be used to show your customers some behind-the-scenes action.

If you are new to the world of Facebook promotions, do not dive indirectly and stay in your comfort zone. Promote your content to the people who know you, such as friends and family. This way, you will get instant feedback, and you can change things if they do not make sense.

Pinterest for the Curator

If you love creating mood boards and like to horde images, Pinterest can be a boon for you.

All other social media platforms are more focused on the present (and perhaps the past), but Pinterest is focused on future events. Business owners who are trend-forward can use Pinterest to register their inspirations and ideas. They can also learn a lot of new color schemes and trends.

Instagram for the Visual Storyteller

If you are high on visuals, Instagram can be the best deal for you. Instagram can be the best tool for you if you are social and like images. Instagram is not only very visual, but it is also quite interactive. You can share a lot of images such as your behind-the-scenes process, the personal ideas of your brand, etc.

You can also display pictures of your works in progress, or they give sneak peeks of your products. Along with this, you can share tours of your studio on the Stories

feature. You can also use creative hashtags to connect with targeted buyers.

If you are still confused about social media, fret not. Just try out a few services until you make a decision. You will find out more about social media marketing and specific social platforms in the next chapters.

CHAPTER TWO

DRIVING TRAFFIC WITH SEO

Tag and Title

Using tags and titles on Etsy is a great (and free) way to attract more shop traffic towards your shop and increase your sales as well. Using strong tags and titles will help your products to get noticed by not only the Etsy search but other search engine giants as well. The title is crucial because it sends your first impression to the customer. Tags are important because they help your product reach a large audience.

Titles and tags often require a lot of trial and error, and they are quite confusing as well. This chapter will help you avoid these basic mistakes and improve your Etsy sales in no time. Here are some tips to get you started.

Forget Being Grammatically Correct

If you love being grammatically correct all the time, you will have let go of this habit (at least in the case of Etsy). All top sellers are aware that you need to put targeted

keywords in the title to attract the right kinds of buyers. But putting these keywords in titles will often mean grammatically incorrect titles.

Many times Etsy sellers try to use grammatically correct sentences. They use filler words such as 'the,' 'of,' 'and,' etc. But these words take up a lot of unnecessary space out of the 140 characters that are available to users. It is necessary to use this limited set of characters as judiciously as possible. Delete any filler words and only add words that your customers may input in the search bar.

Another problem that new sellers face is naming their products in a weird manner. If you name your product line something exotic, your customers will not find them with ease. Your title should contain some targeted keywords so that your customers can find the products.

Place Your Strongest Keywords at the Front of Your Title

As said in the previous chapter, the first 30-45 characters in the title are the main characters. You need to input your most crucial keywords here. If you do not know which keywords to use here, just check the stats of your product. Use the top 3 keywords and then arrange them in front of your title.

The initial keywords in the title can also help your products turn up on search engines such as Google.

Your second most important keywords should follow your most important keywords.

Use All 140 Characters of Your Title

Do not skimp words; use all 140 characters available for your title. As said above, the first 30-45 characters need to be your most popular keyword. You can use the final characters for the longtail keywords.

Longtail keywords, as the name suggests, are long, and generally contain specific words in relation to your product. The specificity of these keywords allows customers to find your products with ease.

To choose longtail keywords, check out your stats. Here you will get some ideas about your potential customers' searches. Adjust these words into the second part of the title. It is also recommended to use the other longtail keywords in tags.

If you are listing a new product and have no longtail keywords to look for, check your competitor's profile. Search for a product similar to your product on Etsy. Check the first three listings and use the keywords used by these listings. These can be used in your tags as well.

Match Etsy Tags with Targeted Keywords

Visit your stats for every product on Etsy individually and check the keywords that are used generally by

people. This can be done for all kinds of listings that are at least in the system for a month. Add the keywords that are high-volume to your tags and get rid of all the tags that do not bring any results or inquiries.

If a longtail keyword is too long, you can divide it into two tags as well. It will have the same impact.

Use Different Keywords

If there is more than one item that falls under the same category or that are similar, do not use the same titles for them. Yes, it may seem easy to just copy your titles, but this will lead to problematic sales. Etsy curates and manages searches differently. This means that if you have multiple products with similar titles, only a couple of them will show up in the search results. If you want all your products to show up in search results, you need to use similar but different tags. Diversifying your keywords is the best way to get new customers and attract buyers. This way, you can display your products to a lot of potential customers.

This does not mean that you should change your titles and tags all the time. You can use different longtail keywords. It will help you come up with new and great keywords.

Revise Your Listing

After every two months, it is recommended to revise your listings. You should revise the tags and the title to attract new customers.

Check the stats of your product on Etsy and check the keywords. You may surprisingly find new keywords that people have been using to search for your product.

Check the stats of any low performing listing every couple of weeks and freshen it up from time to time. If a listing is performing particularly badly, revise the longtail keywords and place the high-volume keywords in the front of the title.

Keywords Research

People prefer to use Etsy over other online retail stores because they know that they will find something special on it. By typing just a few words into the search bar, the users can find anything they want. Etsy search is designed in such a way that it can help all kinds of shoppers to find whatever they are looking for.

The Essentials

The keywords that the seller uses in titles, tags, attributes, and categories all work simultaneously to help the customer find the products. Whenever the user searches something, and it matches the keywords used by a particular seller, the products have the possibility of showing up in the search results.

Etsy search collects all the listings that contain the keywords that the customer puts in the search bar. Then these listings are ranked according to the keywords and relevancy. This means if the seller uses a strong keyword in his or her product listing, the listing will have more chances to show up in the search results. Let us have a look at some common tips that can help your products to show up in search results effectively.

Categories

Categories are quite similar to tags, and in categories, you can add a variety of options that are relevant to your requirements. Adding specific categories can enhance search engine results. Whenever you add sub-categories in your listings, the items automatically get segregated in all the categories that you have added in a nested form.

As categories are like tags, you should not repeat the date used in tags. Keep your attributes, categories, and tags all different. This way you can make your product really popular.

Attributes

Attributes, as the name suggests, are extra details that you can add to your listings. This can be done once you choose a category. Attributes can really help your products pop and standout between hundreds of search results in the same category. Attributes include paint, size, shape, and many others.

It should be understood that all attributes act like tags; this is why you should only use relevant options even if they do not make semantic or syntactical sense. This means that even if your product is turquoise-colored, you should still add blue to your listing. Similarly, if you put in 'nature-inspired' for your product, you should also add 'trees and plants' as attributes.

There is no necessity to add tags that are totally similar to the attributes. For instance, if you write 'blue shades' to the attributes, you do not need to add 'blue shades' as a tag once again. You can add multi-word descriptive tags, though. So you can add 'elegant fur blue shades' as a tag.

Titles

Keywords are important in the case of titles as well. These are necessary because they allow the consumer to search for your products with ease. But titles, while important, are not the most important thing for Etsy, they are just one of the many keywords that Etsy searches for.

A seller should always write a clear, short, and descriptive title for the ease of convenience of the customer. Always add your most prominent keywords to the front of the title. You are also allowed to use punctuation marks in your title to separate the phrases; it will not affect your search in a negative way.

Do remember to add the most descriptive keywords in your title. Also, remember that you are trying to sell your products to a person and not a computer and write your titles accordingly.

If the seller adds a lot of keywords to the title, it may confuse the customer, or may even put them off. But if the seller does not add enough keywords, the product may not turn up in the search. This is why the seller needs to seek the middle ground and come up with a title that not only contains all the keywords but is comprehensible as well.

Tags

A seller can add 13 phrases to his or her listing to describe the product. Each tag that the seller adds to the listing makes his or her product more attractive and

search worthy. The seller should spread out his or her tags as much as possible. Let us have a look at some dos and don'ts of tagging:

Tagging Do's

1. Use all the tags available as each tag is, in a way, an opportunity for you to sell the product.

2. Use multi-worded tags. You can add tags that are 20 characters long. You can use multiple phrases in tags. For instance, if you add a 'custom wallet' as one tag, you will be able to save the space of another one.

3. Check your Shop Stats. Check out the tags that are not receiving enough traffic. Change them around.

4. Use synonyms. If you sell bed covers, you need to tag your product with bedsheets and bed covers both. This way, a customer will be able to look for your product by using synonyms as well. Etsy can take into account the 'jewelry' and 'jewelry' confusion, but it won't consider all the synonyms on its own.

5. Understand and use regional phrases. If you plan to sell flip-flops throughout the world, it is necessary to add all the regional varieties to the tags. You need to add 'thongs,' 'thongs sandals,' 'slippers,' 'floaters,' etc. to the listing.

6. Use longtail keywords. Instead of using simple and especially generic keywords for your products, use less popular phrases that describe your product to T. Target, the shopper who knows what they are looking for.

Tagging Don'ts

1. A seller can use 13 tags in a listing. All these tags should always be unique. Do not use repeated tags. Make them unique. For instance, if you add 'leopard print' as a tag, do not add tags such as 'leopard art' 'leopard skin art.' Diversify your tags as much as possible.

2. Never repeat attributes and categories. The attributes and categories both function like tags. Do not add the phrases that you have used in categories as tags again.

3. Do not use misspellings. Many times sellers try to add misspellings to their tags because they are worried about misspellings from the customers' side. This is a valid concern, but Etsy takes into account all the common misspellings. It will direct customers to your listing even if you make a minor typographical error.

4. Do not add tags in different languages. The tags and titles should both be in the language that you used to set up your shop. Etsy translates the tags and titles on its own. Or you can translate the listings on your own if you desire to do so.

5. Do not worry about adding plurals to the listings. Etsy only looks at the root words while searching for listings. This means that even if you add 'diamonds' or 'diaries' to your tags, Etsy will still direct customers looking for 'diamond' and 'diary' to your listing.

How to Think about Tags

As said previously, it is crucial to use all the 13 tags and make them unique. To make your tags unique, you need to think about what makes your products unique as well. It will allow you to think about what shoppers think about your products. As the character limit of the tags is just 20 characters, you will have to be as creative as possible. If you try to use a keyword phrase that is longer than 20 characters, it is recommended to divide them into more than one keyword. Breaking the phrase into multiple tags will not affect your listing negatively. But do not divide the phrases into single-word keywords, as they will take up unnecessary space.

Descriptive tags that are accurate and clear will help you describe your products thoroughly. But there are various other kinds of tags that you can use.

Descriptive

The categories added to the listings need to describe what the product is. There should also be some tags that should describe your product in your own words. Just

remember that it is better to use multi-word phrases instead of using individual words.

Examples: vintage cat brooch, reusable envelope dots, polka ceramic cup, set of eight coasters

Materials and Techniques

The seller knows his or her product better than anyone else. Try to add highlights that make your product unique. For instance, if you sell customized items, it is crucial to add phrases that will convey this message to your potential customers. Try to be as specific as possible.

Examples: Customized wallet, engraved keychain, reclaimed wooden frame, custom handkerchiefs

Who it's for-

Make your content unique and customized. Your potential customer should be able to check your product and know for whom it is made. Think of your potential customer in such a way that he or she is trying to gift your product to someone else.

Examples: Gifts for girlfriends, gifts for weddings, gifts new moms, professor gift

Shopping Occasions

An excellent seller always puts himself or herself in the shoes of the customer. He or she understands the various occasions when people tend to buy things. For instance, imagine that you are hosting a party. What kind of things will you search on Etsy to make your party memorable? Describe your things using these keywords.

A quick reminder: Occasion attributes need to incorporate descriptions that are relevant to the occasion. This does not mean that you cannot add tags to products that are not strictly meant for these occasions but can be used thanks to their relevancy. For instance, while stockings are strictly not made for Christmas, they can be used for the holiday. To make them more relevant, you can add the word Christmas in front of stockings so that the customers will be able to find the products with ease.

Solution-Oriented

You can also make your product's solution-oriented and tag them similarly. For instance, if your products can help people in one way or another, it can be a great gift to the person. Certain solution-oriented products include headbands, indoor pots, lunch boxes, etc.

Examples: closet organization, lunch box decal, workout headbands, and indoor garden

Style

People tend to have a personal aesthetic or style that helps them make proper decisions regarding their clothes because people like to show off their style and charisma to the world. You can tap into this and can adjust your tags accordingly. You can use these tags to reflect various style choices and preferences.

For instance, you can use style palette, time period, aesthetics, etc. that match the products that you plan to sell. You can combine the name of the product with the style or time period to make a multi-phrasal tag.

Examples: Minimalist ring, art deco lamp, rustic wall decor, typographic print, etc.

Size

The size of the products can also help you decide the attributes of your keyword. For instance, you can add tags that describe the shape and size of your product.

Examples: Deep basket, small beach tote, teen pants, large silver hoops

Tools for updating your titles and tags

If you want to use the above tips in your shop, there are some methods that you can use to make rapid changes. You can either remove or add a tag from many different listings simultaneously by checking the boxes on these listings in the Shop Manager option. Just click on Editing

Option, followed by Edit tags. You can also edit your tags and titles with the help of the Quick Edit tool. You will be able to make quick updates without having to click on each listing separately.

Ranking

Etsy is a great eCommerce platform that is brilliant for sellers who plan to sell unique products. It is now considered to be the fastest-growing e-store all around the world.

If you want to become a successful seller on Etsy, you need to use the Etsy SEO service and strategies carefully. In the past, the process of optimizing Etsy listings was simple. This way, sellers could ensure the higher rankings of their listings. Sellers only had to fill some key areas in the listing forms, but now times have changed because the technology has evolved. The search algorithm for Etsy is revamped and is now controlled by AI or Artificial Intelligence. This has resulted in a smarter search engine, which is great for buyers but not so great for vendors. But this does not mean that the vendors cannot use the new search engine. You just need to update yourself and your techniques.

How Does Etsy Search Work?

Before moving on how to optimize the search engine, let us first have a look at the functioning of the Etsy search engine in brief.

1. Tag and Title

The current search option of Etsy is like Google. In Google, the title and tags of a product need to match the search query of the consumer. Similarly, the search query of an Etsy customer needs to match the seller's tags and titles as well. If the search terms do not match or not present at all, the listing will not be included in the results as well.

How to solve it?

It is true that sellers cannot control some ranking factors, but they can always conduct research and curate the product description in such a way that it will include all the tags, the title, attributes, and descriptions properly. Instead of focusing on the listing, in the beginning, you should always focus on the description of the product.

Let us have a look at some simple tips that can help you create a comprehensive and useful product description:

a. The product title needs to be search-friendly. If the product has the exact (matching) term, then the term should be given a high priority. Always check the product descriptions of similar products sold by other sellers. Try to write a product description that is similar to these descriptions.

b. Always try to incorporate relevant keywords as well as longtail query terms in your description. As said above, sellers can add 13 keywords in their tags. Use all these.

c. While you can make a 140 characters long title, the search generally shows only the first 55 characters. This means you're your keyword needs to be in the first 55 characters. This will not only help the customers to know the nature of your product, but it will also help with the integrated Google Shopping experience.

d. Tags and titles are used by Etsy search engines. These search terms are relevant intentionally as well as commercially. Use these tags as much as possible.

2. Attribute Relevance

Attributes are relevant as far as search is considered. Along with tags and titles, attributes are important as well, as buyers often tend to search for products using terms like 'Black dress shoes,' 'Small skirt,' etc.

How to solve it?

You should always choose the category of the product first and the sub-category of the product later. It will help you choose the types of attributes for your products. These attributes can include size, color, and many other things as well. It is recommended to select as many correct and relevant attributes as possible. These attributes should be related to the product that

you are listing. It will help you to expose your product to a multitude of customers.

Choosing the relevant categories is important because it can help the buyers to find your products with ease. It is crucial to add specific information to your products. This way, the users will find your products with ease, and they will buy them immediately.

3. Quality of Product Listing

The more favorites, clicks, and purchases a listing receives, the more will be its chances to do well in the search option. This factor is known as the 'listing quality' of the product. But with new technology, listing quality is becoming obsolete, and Etsy has neutralized it. In new shops, it plays little to no role in search results.

How to solve this?

Etsy uses an automated option in this case. The products that get the most attention, i.e., more clicks and purchases and which have high conversion rates, are given preference over other products. Do pay attention to the uniqueness of your products. You need to work hard. The quality of your products needs to be excellent.

Tips:

- Always make sure that your buyers are getting an excellent experience.

- Ask your buyers to leave positive reviews on the product pages.

- Add the seller's policy clearly in the About Us section of your shop.

- Do not price your products too high or too low. It will lead to fewer clicks. Conduct some research to check your competitions' prices. Come up with proper prices after research.

4. Regular Updates

Etsy's search engine algorithm generally prefers the product that was updated recently. It pays ample attention to the listing or relisting dates of the products.

How to solve this?

To keep your listings fresh, update the title, details, and tags of your products frequently. It will help you keep your content up-to-date and fresh all the time.

5. Shop Location

Etsy search takes into account the shop location of the vendor to make search results more suitable for the customer. This means if the customer searches for a product in Australia, he or she will not see the store situated in the United States on the first page of the

search results. The shop location needs to be proper to make the rankings perfect.

How to solve this?

The main motive behind this location business is to ensure quick delivery to shoppers. Third-party vendors have no option to deal with this, as they have no control over this phenomenon.

6. Artificial Intelligence

According to Etsy, they are trying to make their search system more intelligent now. This way, the searches will be better and more relevant. They have incorporated various factors in the search results such as preferences, time of the day, etc. This is good news for buyers because it will help them to find products with ease, but it is bad news for vendors because these provisions may lead to selling and tagging problems. This because whenever the user types in a keyword in the search option, he or she will not see the same results every time.

How to solve this?

It is true that the latest technology is making things difficult for vendors on Etsy, but there are certain tricks and tips that can help vendors to keep their business afloat and thriving. Let us have a look at these tips:

- **Etsy Rank**

This is a rank checker tool that can search Etsy for all your items and can filter personalization results as well. It is available for free. It can filter bulk reports as well.

- **Etsy Stats**

The sellers are able to use the 'Search Terms' section to check which keywords the customers are using to look for your products.

7. Listing Language

When a person signs up on Etsy, it is crucial to list products in the language of his or her shop. All the listing information for all the products needs to be in the native language of the Marketplace. So, if the Marketplace is in the French language, then do not use English Keywords, or these keywords will not be recognized by the website.

How to solve it?

The listing information that the seller puts on Etsy should always be the same as the language of the Marketplace.

8. Relevant Linking

Links are good for the search engine ranking. It is recommended to link your shop page to the policies and the products listed on the Etsy Marketplace. Your shop

page should consist of the following information: Shop Name: The name of the shop.

- Shop Description: What your shop entails and what you plan to sell.

- Sales Count: How many sales you made in the past.

- Start Date: When you opened your shop.

The shop page information is available at Marketplace. This information is great because it allows you to enhance the visibility of your product and promote your shop as well. Similarly, it will also help your products to become more popular.

CHAPTER THREE

FACEBOOK MARKETING

Nowadays, people are always on a lookout for promoting their products on various sites and services. But many sellers who own a small-scale business do not want to spend a lot of money on this. Facebook, along with various other social media platforms, can help you do this, along with various other things with ease.

Facebook is now being used by many eCommerce business ventures, including Etsy shop owners throughout the world to promote their products without spending a lot of money on advertising. Anyone can use Facebook ads to grow their business if they learn how to use it. You just need to learn how to use the basics of the platform.

This chapter will serve as a guide for all the people who want to start using Facebook as a way to increase their

business. Facebook, if used properly, can improve your business.

Why Use Facebook for Advertising?

There are many different options available on the market that can be used by small-scale business owners, such as Etsy shop owners to promote their products. But Facebook is perhaps the most popular one because it has these three characteristics:

1. Driving Traffic from an Active and Engaged User Base

Facebook is a social website where people tend to connect to their friends and family. A lot of people hate Facebook because it is extremely addictive. But this addictive nature of Facebook can prove to be an asset to you. According to reports, around two billion people use

Facebook actively each month. These users spend more time on Facebook as compared to any other social media site. With this, Facebook now also owns Instagram and Messenger. Both these mobile apps are extremely popular as well and are good for advertisements as well. You can divert these people towards your business page and, in the process, increase your business.

2. Targeting Customers

With the help of Facebook, you can target your customers using various parameters such as their age, gender, and various other demographics as well. This is because Facebook is designed in a manner that people tend to share their personal updates on it. These personal updates include vacation pictures, songs that they like, movies that they watch, etc. All the connections and likes that these people create on Facebook are used to generate a user profile that can be used to create targeted ads. Facebook advertisers can then create ads in such a way that their targeted demographic will want to buy these products. This way, your product will reach a lot of people and increase your sales as well.

3. Generating Brand Awareness

Nowadays, a lot of businesses have an Instagram or a Facebook business account. This way, they can connect with their customers and fans through social media.

Once you decide to use Facebook to promote your shop, you need to create a social page for your brand. This way, you can expose your brand to a lot of new people. Social media can help you reach new people and new potential customers as well.

Step 1: Setting Up Your Facebook Business Manager

While many people start using Facebook advertising in the beginning, they give up soon because they think that it involves a lot of effort. But, if done properly, Facebook advertising does not require a lot of effort. Many people get overwhelmed by Facebook's multitude of options. These options confuse many people, and they end creating strange ads.

To begin things properly, you need to set up your Business Manager account properly.

Business Manager is the special option available on Facebook that contains your business page, your ad account, and all the other tools relevant to your advertisement purposes.

To create your Business Manager account, visit business.facebook.com, and click Create Account. Here Facebook will ask for the name of your business, followed by your business page details, your email address, and your name. If you have not created a page for your business already, do it immediately.

166

After this, you will have to create an advertising account. You can also add an already existing account. To add an account, you need to use the Business Settings account available in the Business Manager Menu. To do this, just click on Accounts, followed by Ad Accounts. You will be presented with multiple options for adding a new or an existing account. If you are new to the world Facebook ads, just click on Create a New Ad account. Follow the steps carefully.

Once you create your Facebook business account properly, you will be presented with a screen that is known as the advertising hub. Here you can view all the different and relevant business areas on Facebook.

Step 2: Installing the Facebook Pixel

One severe problem that many new Facebook advertisers face is of 'presence' of ads. This means that there is no way to check whether your ads are working or not. You can set up advertising campaigns and can boost posts using Facebook Ads Manager, but it won't help you check the relevance of the ads. To do so, you need to install the Facebook pixel. Here you can check whether you ad really helped you get sales or not.

The Facebook pixel serves as a link between Facebook ads and your Etsy shop or your special website. It is a tracking code that you need to create in the Business Manager account. It can then be added to your website

before purchasing the ads. This code will allow you to see all the visitors (and their actions) on your website through Facebook ads. The pixel will help you understand which ads brought people to your page, which ads made them buy things, and which ads did not work at all. It will allow you to make better ads that will tap into your potential customer base properly.

Step 3: Creating Facebook Audiences

It is necessary to learn how to target your core audience carefully with the help of Facebook advertising. Facebook has billions of users around the world. You need to work hard to target your customer base carefully.

You can create a target list of people in your Business Manager. You just need to access the Audience section in Business Manager. There are many different options available in this section through which you can define your customer base. All these options can be divided into two sections: Prospecting and Retargeting. Let us have a look at both of these ones by one.

Retargeting: Converting Warm Audiences

A person who visited your website or your Instagram and added something to the cart is more likely to buy something from you as compared to other people. But you need to push these people a little to encourage them to make the purchase.

Many times when you browse the website or the page of a brand, Facebook tends to show you ads related to the brand. This is known as retargeting. It is one of the best and effective features of Facebook advertisings.

It is possible to create a retargeting audience with the help of the Custom Audience feature. This feature is situated in the Audience section of the Business Manager option. Custom Audience allows you to use all the data captured with the help of Facebook pixels along with business pages.

A lot of different sources are made available to the seller when he or she decides to create a Custom Audience. The three major sources include website traffic, customer file, and engagement. Let us have a look at these three ones by one.

1. Customer file

In this source, you can upload a list of phone numbers, email addresses, and all other relevant contact information that you collect from leads or customers. Facebook will then match these parameters with its users so that you can target the audience who will be interested in your products. Using the customer file to create an audience is a great way to re-engage past customers and meet new customers as well. You can also reach the customers who have not made a purchase yet using this method.

2. Website Traffic

This source allows you to create a retargeting list that can help visitors to reach your web page. In this method, you can create lists of many different sizes. The size of these lists depends on the pages visited by your customers and the actions taken by them. Generally, these lists contain all the users who have visited your page in the past month. It also includes customers who added some products to their cart in the last week.

3. Engagement

If you have created an active Instagram or Facebook page for your business, you often get sharers, commenters, and likers. You should try to use these for your own benefit as well. To do this, just click on Select Engagement from the Custom Audience option. Here you can create a list of various types of engagement that can be retargeted. This service will help you target all the people who have ever liked or commented on your page by checking whether they will be interested in purchasing products from you, or not.

Prospecting: Finding New Customers

After the retargeting, the other crucial method of Facebook advertising is prospecting.

While retargeting allows you to contact people who know your business or have bought something from you

in the past, prospecting allows you to contact new users. This way, you can find new customers and increase your sales with ease.

In terms of advertising, looking for new customers is also known as 'prospecting.' In this method, you create ads that target people who have never interacted with your business or have never bought anything from you. For medium and small-sized businesses, this includes almost billions of active users present on Facebook. It is impossible to target all these people, which is why you need to narrow the list down.

Facebook has made a couple of tools available to users to make this process simple. Let us have a look at these tools individually.

1. Lookalike Audiences

Facebook can create a list of prospective buyers for you by using the list of your past customers. This method is known as Lookalike Audiences. Facebook can use the data present in Custom Audiences to create a new audience to find a new audience that shares similarities with your old or existing customers.

It is possible to create Lookalike Audiences using a variety of options available in Custom Audiences.

2. Interests, Behaviors, and Demographics

171

If you do not possess a list of your past customers, you cannot create a Lookalike Audience. You can still use Facebook's behaviors, interests, and demographic data to solve this problem. You just need to use the saved audience option for this.

Let us have a look at all the above categories one by one:

- Interests include all the content and Facebook pages that users interact with. This includes music groups, book-related pages, adventure sports, etc.

- Behaviors include all the actions that users perform on Facebook. This includes getting married, moving to a new city, joining a new institute or job, etc.

- Demographics include the user's profile information, including their education, gender, etc.

You will have the option of checking many different audiences to test from. This can prove to be quite confusing, but you can narrow these options by identifying the categories for testing. To make this process simple, you can use the Audience Insights option that is available in the Business Manager section, which is available in the Plan section of the main menu. Here you can use your Facebook page and can also input

the demographic information about your customer base. This tool will then show a lot of information about your potential customer base, including what pages they generally like and spend time on, what devices do they use to access Facebook, where do they live, what are their likes, etc.

This information collected by Audience Insights can then be used to find new interests and can ultimately be used to target new customers as well.

The behavior, interests, and demographics of audiences are quite extensive, and you will find thousands or even millions of users online with similar interests, so it is recommended to check the above three criteria personally. It will allow you to narrow your ads even more, and you will be able to target the audience properly.

Step 4: Creating a Facebook Campaign

The ads present on the user's feeds are generally accompanied by the word 'sponsored.' But you will be surprised to know that these ads are just the tip of the iceberg.

If you want to promote your products successfully on Facebook, you need to create an ad campaign. The ads mentioned above are just a part of these campaigns. In fact, in every single campaign, there exists a multitude of ads. Here you can choose your budget, your audience,

and then your target group. You can also select which ads the users will see. As a single campaign contains many different ad sets, you can check the ads and the set of ads on different groups of people to check their effectiveness and relevance.

Choosing an Objective for Your Campaign

Before creating an ad campaign, you need to form the objective of the ad campaign.

To create an ad campaign, go to the Ad Manager tab, which is present in your Business Manager account. Here click on Create Button. Here, you will have to insert an objective for your ad campaign.

Generally, objectives for Facebook ads can be divided into three categories; these are:

- Consideration

- Awareness

- Conversion

Each category contains a list of many different options, for instance, video views, traffic, product catalog sales, etc. You need to consider the motto of your business and what you plan to achieve from your ad campaign. The answers to these questions will help you choose an excellent ad campaign manifesto. Here are some

examples that will prove how different goals can affect the objective of your ad campaign.

If you plan to increase sales in your shop, you need to set your objective to Conversions.

● If you find it difficult to sell products through your shop, you should choose the Add to Cart button. Generally, this objective is more cost-effective as compared to Conversions.

● If you are not selling a product yet, but just want to create a buzz or awareness of your product, you can do so using the Brand Awareness objective. This is also a cost-effective option.

● If you are selling products but don't have enough Traffic or are finding it difficult to drive traffic towards your web page, then you can choose the Traffic objective. This will allow you to create a retargeting list.

● If you want more comments, likes, and shares on your social media posts, use the Engagement objective.

Whatever objective you choose, Facebook will always charge you according to the number of impressions or the number of people that saw and interacted with your ads. It is crucial for you to communicate your objective so that your ads will be optimized according to your ultimate goals. If you select Traffic but want to increase purchases, you may or may not get your desired results

because your chosen objective does not match your goals.

Before creating ad sets, you need to name your ad campaign as well. It is not a thing that can be overlooked.

Naming your ad campaigns can help you keep things sorted. It will reduce the confusion and also help you keep your account well organized. By naming your ad campaigns properly, you can check out their objectives instantaneously. Your campaign names can also help you with your target audience at one glance.

How you choose your names depends on you. The only thing that you need to remember is to name campaigns in such a way that you will be able to navigate the campaigns with ease.

Step 5: Setting up your Ad Sets

Once you choose the objective of your ad campaign, you need to set the ad set level. Here you are presented with many different options, including:

- Which audience you plan to target

- Your budget

- Where do you want to put your ads in the network of Facebook and Facebook products?

You will have to provide various data, including the type of events and objectives. For instance, if you have chosen Conversion as the objective to gain new sales, you will have to select the conversion event that will match with your goals.

Setting Your Budget and Schedule

The next crucial set for ad sets is the budget. You need to input your budget and then choose whether the budget will be a lifetime budget or a daily budget. Choosing your budget can be quite confusing, to make the process simple, consider the following things:

- Your budget for marketing. If you cannot afford a lot or marketing, do not waste money. Find cost effective methods.

- Cost of production: If your production takes a lot of money, adjust your marketing accordingly.

- Cost of Product: If you plan to sell your product at a higher price, you will have to keep your marketing budget high as well.

- Your Objective: Generally sales-focused objective needs a lot of marketing budget as compared to awareness-focused objectives.

- Customer Acquisition Cost: You need to take into account your average customer acquisition cost. It will help you set up your budget properly.

Remember to give a fair shot to Facebook ads by allotting them a decent budget. If you really want to achieve your goals, you should take marketing seriously. Once the ads go live, you need to allow some budget and time to the 'learning phase' of Facebook. In this phase, the algorithm of Facebook checks your data and starts optimizing to achieve your objective successfully.

Audience

In the ad sets, you will have to choose and refine a retargeting or a prospecting list that you created in the Audiences section. Choosing the gender, location, ages, and languages option can help you narrow down your audience. It will also allow you to test your ad sets with different demographics.

At the bottom of the page, you will also find an option through which you can conduct detailed targeting with the help of Facebook interests, behaviors, and demographics. Here you can choose categories that can help you create a new audience that can be layered on the top of your current audience.

At the ad set level, it is also possible to target people on the basis of a Connection. This can be done by tapping into the list of people who like your business, app, page,

and events. You can even entail their friends. If you have a lot of people who come under these categories, the targeting based connections can help your app significantly.

Placements

Ad sets also allow you to control and choose where you want your ad to appear. As mentioned earlier, a lot of popular apps, including Instagram, are owned by Facebook. Ad sets allow you to place your ads in these apps as well. It is solely up to you where to put the ads.

Step 6: Choosing Your Creative (Your Ad)

The last step is to create your Facebook ad in a creative way. The advertising on Facebook as a platform is quite different than other traditional forms of advertising.

When you want to create an ad on Facebook, you are presented with options to select the Instagram account or Facebook business page where you can present your ads. This is great for your brand because it can help you create awareness of your brand. Even if it is not your main provision, it can still help you create a great brand.

Retargeting with Dynamic Product Ads

The dynamic product ads are used heavily on Facebook. If you have ever checked an online store where the page retargeted you to similar products that you viewed in the

past, this is a form of dynamic ad. These ads use the data presented by Facebook pixel data along with the Facebook product catalog.

Step 7: Optimizing your Facebook Campaigns

One of the first and major steps that you need to take to make a successful Facebook ad is creating the ad campaign. You also need to learn how to optimize and monitor the performance and progress of the campaign. It will help you achieve great success. It is recommended to check your Facebook ads at least once a day. If you can do it more than once a day, that's great!

It can be quite tempting in the beginning to make changes in the targets or even switch off the ads completely if you do not see purchases in a couple of days, but it does not matter. You just need to be as patient as possible.

Facebook ads need a lot of optimization time. This is important because the algorithm requires a lot of time to optimize things carefully. If you want to switch off your ad, wait for a while, and check whether it gets 1000 impressions or not. If it does not receive 1000 impressions, then you can either invest more money, or you can always shut it down. Just give it ample time.

Creating a Funnel

Remarketing and Prospecting are two important tools that can help you get a good audience, but you need to use them together to make them even better. When both these are used together, a 'funnel' is formed.

A funnel is an interesting marketing strategy that works off the premise that not a lot of people on the market are ready to buy something right at the moment. The funnel marketing strategy uses this concept to create a marketing plan that is tailored to the audience and their purchasing interests. It allows you to target your audience and become familiar with your product and your brand.

Creating a funnel on Facebook can be done with the help of a cold audience, using options such as Lookalike Audience. Or you can also use the behavior-based audience in the campaign. Then you can retarget the visitors that you receive from the last campaign to another campaign.

With time, your budget will increase, and similarly, the funnel system will become more intricate and complex. This way, you will be able to target a multitude of customers within the funnel with ease.

If any time you feel that Prospecting is not creating a lot of profit for your business, you should choose a high funnel objective, which will be less expensive. This

includes traffic objective or objectives. You can create a list of prospects to retarget in another campaign.

It will lead to the formation of a funnel using your Facebook ads. This way, you will be able to target many different demographics of the audience, and your purchases will increase.

Start Using Facebook Ads to Grow your Business

The advertising platform that is available on Facebook is designed in such a way that even people who have little to no digital marketing experience can create and run excellent ads.

You just need to learn the basics of Facebook ads and set up your accounts properly. Next, launch your campaign and then watch your business grow exponentially.

How to Convert with Facebook Ads

Facebook keeps on introducing new changes to its layout. It also changes the algorithm for News Feed quite often. Every little change in the algorithm is crucial for sellers who promote their products on Facebook, as you need to adjust your ads and advertisement strategy accordingly. This is especially true for people who own small-scale businesses and who do not have a large budget.

One of the crucial metrics that social media marketers track with the help of Facebook is the conversion rate. Conversion rates mean the point at which a general user becomes a buyer or a customer.

For many marketers, converting general browsers to customers is extremely important. If your service has a good conversion rate, it means that your business is successful.

Conversions are also responsible for driving action. The goal of any campaign is to increase the number of subscribers to newsletters. Ultimately, all the actions that can help your browsers become customers are conversion actions.

Facebook is considered to be the top most used social media website that creates a lot of conversions. To make the conversions even more effective, it is recommended to create effective and proper Facebook ads.

Here are some tips that can help you make your Facebook ad campaign a grand success.

1. Define Your Conversion Event

Before you try to convert users and regular browsers, you need to check out what actions you want people to perform once they interact with your ad.

Facebook supports many different kinds of conversions, including Add to wish list, view content, purchase, and initiate checkout. It also allows you to create custom conversion events as well.

If you create just one ad, do not expect it to cover all your bases. You need to create a separate ad for each individual goal. Target the ads carefully so that their sequence should make sense.

2. Keep the Destination in Front of Mind

An ad is closely related to its landing place. If your ad is exceptional, but your landing page is boring, the Conversion will not take place. If you genuinely want the Conversion to happen then make sure you make provisions that will help you deliver the promise you made in your ad.

Here are some tips that can help you make a proper landing page:

Pixel

Use pixel. Once you check the page where you want the Conversion to take place, you need to add the Facebook pixel code to the page. This will help you track the event.

Continuity

If your ad promises something, your landing page needs to deliver it. The customer should not have to look for the products that he or she saw in the ad. The design and language of the ad should be replicated on the landing page as well.

Optimized for Apps

A lot of people use their cellular devices to browse Facebook. Your ad should be optimized in such a way that it can be integrated with the app.

3. Create Eye-Catching Visuals

You need to make your ad as eye-catching as possible. First impressions matter a lot in the case of social media ads. If you add in proper design aspects, visual, and sound effects, your ad will stand out, and people will be attracted to it.

Try to keep the text limited. Use it as sparingly as possible and avoid it completely if you can. Instead of using a lot of text in the images, use images that are bold and attract the attention of the audience. If you still plan to use text in your image, you can use Facebook's Image Text Check tool. This tool will help you check the rating of your text to image ratio.

- Size: If your image has low resolution, it will not bode well with the customers.

- Videos and Gifs: Try to use videos and Gifs in your ads. Users are more attracted to moving imagery compared to stable and static imagery. As many people tend to use Facebook on mobile phones now, try to make vertical videos for mobile devices.

4. Keep Copy Short

Do not make long ads. No user will read the ads if it incorporates lengthy descriptions.

- Personal: Try to use personal pronouns in the ad. It will help you form a personal relationship with the audience and the brand. Do not use 'we' in the beginning. 'We' is better for returning consumers.

- Jargon: Try to keep your ads as simple as possible. Do not use unnecessary technical jargon that regular users may or may not understand.

- Brevity: Keep your text and ad as brief as possible. Too much text and information can be too intimidating for users. You can use the Hemingway app to keep things brief.

5. Include a Direct Call-to-Action

The main focus of conversions is about motivating people to do something. To do this, you need to incorporate a strong call-to-action in your ad. You should use strong verbs like Discover, Start, Find, and Explore in your ad. Your main goal should always be directing people towards your landing page.

If you want to drive people to subscribe or make purchases, use phrases such as 'sign up' and 'buy now' or 'free'.

6. Broaden Your Audience

When you plan to create an ad, try to use the "targeting expansion". This way, Facebook will work towards finding users who are similar to the "interest targeting section." It will help you reach a variety of people, and also help you create more conversions at a cheaper rate.

You can also create a Custom Audience to create more conversions. If you possess data sets such as email lists of the subscribers, you can upload it to Facebook. Facebook will use this list to find your existing customers. The list of existing customers can then be used to find a Lookalike Audience. This audience will be your new audience who have similar or the same interests.

7. Optimize for Conversions

It is crucial to check off the 'conversions' box on Facebook. This box is present in the "Optimization for Delivery" section in the Budget and Schedule form.

By clicking on this box, you can increase the effectiveness of your campaign. While it is not absolutely necessary, it is worth trying.

8. Choose the Right Ad Format

There are many different ad formats available on Facebook. It depends on your goals what kind of ad format you should use.

Here are a few things to remember while choosing the right format:

- Collection and carousel ads are ideal when you have several different features, services, or products that you want to highlight.

- Offer ads are great for letting people know about purchase incentives such as special offers, special discounts, and deals. Facebook will send the users notifications to remind them of these deals.

- Canvas ads are great for high-impact images and experiences that are best viewed on full screen.

9. Track across Multiple Devices

It does not matter where you have planned the Conversion to happen, you should still track all the conversions and clicks from mobile to desktop. Even if your campaign is solely focused on the desktop, it is recommended to install the Facebook Software Development Kit on your mobile. This will help Facebook to find more audience data and increase your target audience as well.

10. Consider Link Click Optimization

If you see that your ad is not creating enough conversions in the initial days, you should check whether Facebook is receiving enough data to properly deliver your ad or not. Facebook needs at least 50 conversions per ad in the first week. If your ad does not pull this many people, then there is something wrong with your ad.

To check how many conversions have happened, just click on the Ads Manager option. Here you will be able to check whether your ads have received less than 50 conversions.

11. Convert Your Analytics into Insights

It is necessary to pay close attention to the analytics of the social media campaign. You need to adjust your ads and marketing strategy according to the analytics. Pay close attention to the things that worked and the things that did not work.

Take notes from your old ads and try to incorporate the good things in your future ads and avoid the negative things from your previous ones.

Now that you know how to create and optimize a Facebook ad that is suitable for conversions, you need to focus on other social media sites and options that can help you market your products and Etsy store. It does not matter which platform you use, the experience of marketing will remain the same. You need to keep things direct, clear, enticing, and consistent.

CHAPTER FOUR

PINTEREST MARKETING

How to Promote Your Shop

People who use Etsy are definitely unique compared to sellers on other platforms. You need to use this uniqueness on other platforms as well. For instance, you need to adopt interesting methods of promoting your product and attracting customers to your shop. Pinterest is a great way to attract users to your shop on Etsy.

Many people use Pinterest for a variety of reasons, but most of us use it to pass the time. It is quite difficult to pull away from Pinterest because it is so addictive. You can browse things nonchalantly, or you can browse things to make plans.

Pinterest is great for Etsy sellers because users who look for your products on Pinterest are more likely to buy them. It is a great way to entice customers. It also focuses on special creative photos and uses a strong search engine. Pinterest can be used to promote your

Etsy store. Let us have a look at how you can use Pinterest to promote your Etsy shop.

How to Promote Your Etsy Shop on Pinterest

1) Create Great Visuals

While it is not a good thing to judge a book by its cover, it is what people tend to do all the time. People tend to judge things on a superficial basis. We judge products as well as accounts on the basis of visual cues.

To make your store and products popular on Etsy, you need to make them attractive, bold, and stunning.

- **Adopt a Pinterest "Style"**

One of the major things that can make your Etsy profile on Pinterest great is by choosing a theme and following it. You should align your themes and profiles in such a way that on whichever page the user lands, he should feel the cohesiveness.

All the pins should look like they are from the same family and that they belong together. This keeps things clean and attractive.

- **Maximize Space with Vertical Photos**

On Etsy, items are categorized in straight rows and columns, but in Pinterest, only the width of the image is limited. This means you create long vertical images. These long images not only look stunning, but they also help you cover a lot of information in one single image. These long pins can really make or break your profiles if you know how to use them.

2) Build a Pinterest Following

- **Curate Interesting and Inspiring Boards**

Etsy is quite a competitive marketplace, which is why many users tend to pin only their products on their Pinterest profile. But this can prove to be contraindicative to your desire. If you want your account to grow, you need to add a lot of Pins and curate your board carefully. Instead of curating just your products, you should curate stimulating and inspiring boards.

These should contain all the relevant trends, topics, and aspirations that people may find interesting. These boards should also be relevant to the style of your brand and the demographics of your customers. This will help followers of your Pinterest to become your customers.

Curating on Pinterest is quite an easy task. You should always use the 80/20 rough guide while doing it. This rough guide says that you should always add 80% of pins that your customers will find interesting, and the rest of 20% should incorporate your products that you plan to sell.

It is recommended to use as many pins as possible from the content of potential customers. You should try to keep your Pinterest as hopeful and cheerful as possible. Your Pinterest should inspire your potential customers to buy your products in a subtle but prominent way.

- **Curate Boards Useful to Your Customers**

You need to learn how to curate boards that will prove to be useful to your customers. For instance, if you sell knitted products, you can create a curated board for new parents who would like to care for their baby and wrap her in warm, soft, and delicate clothes. If you think that your products will be useful for parents doing newborn baby photography, curate boards dealing with photography tips and ideas. But, remember to maintain

the unique style of your board and store. Your theme should not change.

If you are still worried about curating boards using other people's content, then just try to distinguish the content and content creators carefully.

Always try to share the content that you find relevant to Pinterest. It does not matter even if the content belongs to your competitor. It will still help you in the long term.

3) Embrace Getting Saves

A phenomenon that many people hate on Pinterest is 'Repin' where other people just share or pin our carefully created board with a strange heading. This is especially true in the case of Etsy sellers whose boards get pinned under 'DIY' or other similar tags. This is why many Etsy sellers try to avoid Pinterest.

The people who DIY regularly do not buy new stuff, but their followers do. For instance, if you Pinboard and DIY-er pin it to remake it, his or her followers may want the same product. And these followers may just check your link and buy the product quickly, because most of the time followers lack the patience, time, and skills for a DIY product.

Repin and other forms of pin engagement are good for your popularity as well because it makes your board popular in the Pinterest algorithm. The Pinterest

algorithm is responsible for deciding what pins and boards are seen by everyone in their feeds. The more the number of engagement and Repins, the better the chances of your board showing up in the feeds of potential consumers.

4) Take Advice from Successful Etsy Sellers

You should try to contact and ask for advice from experienced Etsy sellers who have been using Pinterest to increase their business. As Pinterest is a large-scale platform, there are many tricks and tips that you need to figure out to use it in the best way possible. These experts can help you figure these tips out.

5) Think Like a Search Engine Marketer

One of the best things about Pinterest is that it is not only a marketing platform, but it is also a good search engine. People generally visit Pinterest because they are looking for something. This is why it is a great idea to promote your Etsy store of Pinterest. It will allow you to target your potential customer base by checking out what they generally search for.

Sit down and brainstorm the phrases and keywords that your customers may search for while looking for your products. You can also use the 'AutoSuggest' option to find simple keywords. To do this just type the first few initial letters of your query in the search box, Pinterest

will automatically suggest the terms that are used the most.

Check out these results. These are important because they are your competitors. To succeed, you will have to make better Pins than these results.

Pin your descriptions with the keywords that you plan to tag. You need to create Pinterest boards that can target the categories of keywords that you find relevant.

6) Advertise on Pinterest

Pinterest is not only a good search engine, but it is also a good place for advertising. If you want to get almost immediate feedback on how your Pins are performing, you can check it using the Clickthrough Rate or CTR option of Pinterest. It is available in the Pinterest Ads Manager. According to PRs, you need to focus on campaigns that have 0.20% or higher CTR.

Once you check out which Pins are generating the most conversions and clicks for you, you can increase their budget and can reach even more people. One of the best things about Pinterest is that you can target people with ads on the basis of their searches. Generally, if a person searches for something, he or she is willing to buy it as well. It is no wonder that search marketing is so popular nowadays.

7) Be Consistent

Etsy and Pinterest both take time and patience. But the fruits of this patience are immense. You need to understand that building a good Etsy store and a Pinterest account both take time and effort. Your growth needs to be gradual but organic. You need to share good Pins constantly. You also need to grow your boards slowly but steadily. This will increase your audience.

By studying many different accounts, it was found that the accounts that share around 20-30 Pins every day grow significantly more than the accounts which share less or more than 20-30 Pins. Apparently, if you share more than 30 Pins per day, it will lead to negative effects, and you may start to see negative growth too.

Creating a Pinterest Profile

If you are not using Pinterest for business now, you should do it as soon as possible. You need to put in the ideas that will help you grow on this platform as this platform is rapidly achieving great success all over the world.

Pinterest is a great combination of a variety of options that make it a good platform for marketing. It is not only a good place to connect with your friends, but influencers as well. It also serves as a productivity tool and a visual search engine.

Pinners use Pinterest to find inspiration for a variety of things, be it vacations, bridal showers, weddings, holidays, or even simple luncheons. Many times these inspirations come through brands, which makes them popular. This section will help you understand the basics of using Pinterest for business and how you can use it to make your business a grand success.

Why Should You Use Pinterest for Business?

There are many reasons why you should use Pinterest for business to promote and market your Etsy shop. Pinterest is currently the fourth most popular social media platform in the United States. You will be surprised to know that it ranks ahead of stalwarts such as WhatsApp, LinkedIn, Snapchat, and even Twitter. It is believed that around 28% of American adults have a Pinterest account. This means that every one in four people in the US uses Pinterest. The number becomes even more striking when you consider the millennial population. Every one in two millennials in the United States has a Pinterest Account.

This, however, does not mean that Pinterest is only popular in the United States. It also plays a significant role in the world. From 2017 to 2019, the number of monthly active users (around the globe) grew by 38%. It went from 171 million to 235 million. This number will continue to grow. Since last year, the number of Pinners who use Pinterest at least once a month increased by a

whopping 28%. Around 322 million people use Pinterest actively in a month.

Visual Search is Growing

Why is Pinterest growing so rapidly? The main reason behind the growth of Pinterest is perhaps the rise in visual searches. People are becoming more and more image-oriented, and they prefer to look at images rather than text. Pinterest is a 'visual discovery engine.' It is one of the most important platforms that offer visual search options. This is a big achievement. Around 62% of millennial and Gen Z population has accepted that they would rather search using images than text. According to Pinterest sources, Pinterest Lens is now capable of identifying more than 2.5 billion fashion and home objects.

Pinterest is Popular with Women—Especially Moms

This should not come as a surprise, but Pinterest is more popular among women compared to men. In fact, it is even more popular among moms. It is estimated that more than two-thirds of the users on Pinterest are women. The number of mothers on Pinterest is high as well. In the United States, around eight in every ten mothers use Pinterest regularly. This is good for your business if you deal with household and baby products.

People use Pinterest to Shop

Some 84% of weekly users use Pinterest to help decide what to buy. According to Pinterest, 55% of Pinners are specifically looking for products. And 83% of weekly users have made a purchase based on the content they see from brands on Pinterest.

Pins Boost Brand Exposure

Pinners have now realized that Pinterest is great for brand exposure. According to a recent survey, around 75% of users have agreed that they are interested in new products compared to the 55% of users who use other social media sites. Around 77% of total Pinterest users have agreed that they have discovered new brands in the past week using Pinterest. This does Pinterest a really lucrative service for small businesses and brands.

Pinterest Inspires People

Pinterest can also inspire individuals because it is ultimately a collection of plans and ideas. A whopping 95% of users have said that they have found inspiration on Pinterest in the past.

On Pinterest, unlike on any other site, a brand can become more than just a brand. It can become a source of inspiration and ideas for people.

Pinterest for Business: Important Terms to Know

Pinterest has its own language that you need to understand if you want to market your products successfully on the website. Here is a small glossary that will help you get started.

Pinner

Instagram users are known as 'grammers, and LinkedIn users are known as members. Similarly, users who use Pinterest regularly are known as 'Pinners.' It is the branded term that defines a person who uses Pinterest.

Pins

Pins are the primary kind of posts that can be uploaded on Pinterest. Pins generally incorporate videos, images, texts, and often link back to the original poster or the source of the content.

RePins

When a user pins a post that does not belong to him or her, this process is known as Repins.

Promoted Pins

Promoted Pins are just like regular pins, except companies pay a money to promote these pins. These pins are generally seen on both the feed and the search results. They include a 'Promoted' label. There are many

kinds of promoted pins, such as app pins, video pins, and carousel pins.

Rich Pins

Rich pins are pins that contain a lot of information. It can include install buttons, price, and other such data. They are available in four types: Recipe Pins, Product Pins, App Pins, and Article Pins.

Shop the Look Pins

To add product tags to the creative, you need to use the Shop the Look pin. This allows users to buy whatever products they see in a pin with just a tap.

Boards

Pinterest boards are just like your regular old boards, except Pinterest boards are digital while the old boards are analog. You can collect and pin a lot of data related to various topics and themes on your board. For instance, you can create a mood board, a shopping board, an inspiration board, etc.

Group Boards

Group boards are just like regular boards, except in these boards, more than one user can add content. Generally, group boards only have around five members.

Secret Boards

Secret boards are visible only to the creator of the board and the collaborators whom the creator has invited. If you create a secret board, a lock sign will appear next to the board name. These boards are great for planning, which you may not want to do in front of the public. These are useful for planning.

Protected Boards

These boards are protected and then generally hold the promoted pins. These are only available to real advertisers. While these boards are seen all over Pinterest, they never come up on profile pages.

Save Button

As the name suggests, this button is used to save things. It is available as a browser plugin for Microsoft Edge, Chrome, and Firefox. You can install it on your website. Whenever a user clicks on the save button, he or she will be able to save the products on his or her Pinterest board.

Audience Insights

Pinterest business accounts can access your analytics using Audience Insights. This can help you learn a lot about how to use Pinterest and which sections of the site and your service you need to track.

Pinterest Lens

This is available for both Apple and Android devices. Pinterest Lens is an app-based tool that allows you to search for 'related' and 'relevant' content on the website by just clicking a picture using your phone. It is a kind of visual search engine like Shazam but devised specially for images.

Pincodes

Pincodes are, in a way, QR codes. They work just like Snapchat's Snapcodes. You can scan these digitally, or you can also scan them from packages, etc. These codes are linked to the user shops.

How to Set Up a Pinterest Business Account

There are three methods that you can use to create your Pinterest business account. These are:

- Converting your existing account to a business account.

- Adding a business profile to your personal account

- Creating a new business account

While the methods are different, most of the steps involved in these three are similar. In this section, let's have a look at how to create a new business account on Pinterest.

1. Visit Pinterest.com/Business/Create

Log out from your personal account. On the new page, click on email and add your new email ID. Create a new password and then click on Create Account.

2. Add your Business Name

Add a description that describes your business in the best way possible. Also, add a link to your website in this description.

3. Connect your Instagram, Etsy, YouTube Accounts

Link your Etsy, YouTube, and Instagram accounts to your profile. It will allow you to get traffic from all the sites. It will also help you track the analytics of your business.

4. Let Pinterest Know if You are Going to Put Ads on the Platform

If you want to run ads on your Pinterest account, it is necessary to specify contact details to the service. A rep will contact you regarding this soon.

5. Edit your Profile

Click on the pencil icon next to your name on the dashboard. You should also change your profile name because Pinterest automatically sets it to your email id.

Always put a photo that represents your brand thoroughly. You can use your logo for this purpose. The dimensions of this picture should be 165 x 165 pixels.

In the about section, do not forget to add a few keywords that represent you and your brand.

Click on the Save button to save your profile.

6. Click Claim in the Left-Hand Menu to Claim your Website

Claiming your website is essential. It will help you track your analytics. The next section will help you understand what claiming is, in detail.

7. Create a Pinterest Board

To create a board, just click on the plus sign above the Create a Board text. Next, add a description and title. Find the board and click on the pencil icon.

Choose the category of your board. This is important because it will help SEO. Be sure and add a good and relevant cover photo.

8. Create your First Pin

Creating your first Pin is an exciting and interesting experience. To do this, just click on the plus sign present on the upper right corner of your dashboard.

Next, add a description and a title. Remember to include relevant hashtags and keywords.

Also, add a destination link and click on it to check whether it works or not. Add a video or an image to the Pin. You can edit these by either adding logos, or cropping, or tripping. You can also add text to the Pin in the Pin editor. Use high-quality files to create pins.

Click on Publish and then select the board on which you want to add this Pin.

It is recommended to install the Pinterest save button as soon as possible. It will allow you to populate your boards from your favorite sites in no time. You can also use Pinterest catalogs.

9. Choose a Cover Photo for your Profile

Setting up a cover photo is simple. Just click on the pencil icon above the image. Pinterest will fill the section with creativity from your pins automatically. You can either choose between pin creative or board creative. According to some sources, businesses will soon be able to add videos as their covers.

10. Add the Pinterest Tag

If you want to advertise on Pinterest, it is recommended to add the Pinterest tag on your web page. It will allow

you to track conversions and also help you understand what activities people do after visiting your page.

Now that you have successfully created your business account on Pinterest, you need to work towards attracting followers to your profile.

Using Pinterest for Business

In this section, let us have a look at the variety of tips and tricks that you can use to make your Pinterest marketing successful.

1. Create Captivating Content

The world keeps on changing rapidly, and if you do not have creative content, no one will bother to check your products. It was observed that around 85% of Pinners like images more than text. But this does not mean that you should only concentrate solely on images. Text is important, as well. At the end of the day, you should create well-crafted pins that deliver on all fronts.

What makes a good pin?

There are many things that make a good pin. Let us have a look at some of them:

Descriptive Copy

It should include information about what the users are viewing. It should attract them. Your content needs to be as enticing as possible.

Vertical Imagery

Almost 85% of Pinners use Pinterest on a cellular device. It is recommended to use a 2:3 ratio for your pins and images. This way, your image won't get truncated. Always try to use the highest quality available. Remember that Pinterest is a visual-centric social media.

Text Overlay

Try to use a headline in your pins so that you can reinforce your message properly.

Branding

Brand your pins carefully. They should not get lost if someone repins them.

Storytelling

If you can create a story through your pins, the customers will appreciate it a lot, and they will be far more interested in purchasing things from your store. Creating a story is one of the best ways to entice customers.

2. Pin Consistently

Social media is not a one off thing (unless you are a famous personality or brand.) It takes patience, effort, and time to grow. You need to pin something at least once a day. This is more effective compared to creating a board and filling it up all at once.

If you find yourself too busy to pin every day, just schedule them on Pinterest or a third-party service like Hootsuite. This will ensure consistency in your account. Do check Audience Insights from time to time and see which content is getting the most engagement. Try to post when most of your targeted audience is online.

3. Plan Ahead for Seasonal Content

Pinners are generally interested in unique products and DIY. This is why they tend to plan way ahead of time. This means that you, as a brand catering to Pinners, need to start planning in advance as well. It is recommended to start planning for seasons and holidays at least a month in advance. The earlier you start, the better.

Holidays and seasons provide great opportunities to brands all over the world. In 2018, more than 56 million searches were done on Pinterest. For Halloween, it was 227 million, and for December holidays, it was more than 321 million.

It should not come as a surprise that holidays can boost a brand's performance. According to Pinterest,

promoted pins that are themed appropriately for holidays and seasons can increase sales by around 22%.

If you do not know how to plan for seasons or holidays, then just visit the Seasonal Insights Planner available on Pinterest. It will inspire you to formulate a proper plan. Next, pick a season or a holiday and create content around it. Be sure and use correct and relevant keywords while creating this content.

4. Use Boards to Connect with Pinners

Pinners will not follow you if you do not give them a concrete reason. Pinners need to find your Pinterest Board interesting. You can create a variety of boards to ensure this. Good and simple DIYs using your products will get you followers.

For instance, if you sell makeup products, you can create pins where you can show how to create particular looks using your cosmetics. You can also create boards incorporating various makeup tips, fashion ideas, new looks, experiments with makeup, etc. A good board will serve to be the launchpad for many influencers. These influencers will make your products and shop popular as well.

You can also use the group board to collaborate on ideas and boards together.

5. Optimize for Pinterest SEO

Users should remember that Pinterest is a visual search engine. Like any other search engine, Pinterest uses keywords so that it can look for things. This is why it is crucial to use keywords everywhere on your profile. You should use them in the pin names, companies, boards, etc. Remember to use keywords in the descriptions as well. Pinners often use Hashtags, which are a form of keywords.

Along with keyword research, you can also use other options that can help you with SEO. You can pin content from your webpage on your Pinterest page.

6. Create a Content Strategy that Delivers

Almost all the searches on Pinterest are non-branded. According to some sources, this number is as high as 97%. This gives new brands a lot of opportunities to get discovered. This is especially true in the case of brands that have good products and great content. If you pair this with SEO strategies, your brand will become popular.

Exposure is crucial, but for a good exposure, you need to create a good content strategy as well. You need to follow this content strategy carefully. Once a Pinner finds your products and your content interesting, you should add him or her to the marketing funnel so that you can turn their interest into a customer.

You should always reconnect with Pinners as soon as possible who interact with you. This will help you become a great seller. It will also lead to exponential growth in the popularity of your brand.

7. Target the Right Pinners with Ads

You need to learn how to target the correct demographics using Pinterest. Pinterest allows users to target ads that are created around keywords. These keywords are subjective to age, interests, location, and various other demographics. Audience targeting is a great option for advertisers and business owners because it allows them to reach difficult to reach groups. You can reach people such as people who have visited your website, people who have subscribed to your newsletter, people who have interacted with your pins, people who have interacted with similar content, etc.

You can also create an 'act-alike' audience that can help you find people who are interested in the same things that your customers are. The people who share the same interests are more likely to buy similar products as well. You just need to input an existing audience in the Pinterest algorithm, and Pinterest will find an 'act-alike' audience automatically.

8. Make it Easy for Pinners to Shop

Users who use Pinterest love to shop. Pinners are always on a lookout for new and exciting products. The sellers

who make it easy to for pinners to buy their products experience greater sales compared to other sellers who do not try at all.

There are many methods to make things easier for buyers. One such method is using the Shop the Look pins. These pins contain specific home décor or fashion items that go well together. These pins link the customers directly to the products so that they can buy the things they like immediately.

A new 'Shop tab' is introduced by Pinterest, especially for business profiles. This tab allows interested Pinners to buy products from a company directly from their profile without having to visit their website. It is a new feature, but it is quite promising.

Remember, your business and Pinterest account; both can be improved if you pay close attention to Pinterest Analytics. Always keep an eye on the Audience Insights and change your plans accordingly.

If you find managing Pinterest difficult, there are many online services and apps that can help you manage things with ease.

Claiming Your Etsy Shop on Pinterest

Claiming your Etsy shop on Pinterest is important because it allows you to check the analytics and status of various things with ease. For many years, the only way a

person could claim his or her Etsy shop on Pinterest was by accessing the back end of the website and by inserting some computer code in the process. But not anymore. Now it is possible to claim your Etsy shop on Pinterest with just a few clicks. The ease of this process has made things really good for buyers and sellers alike. In this section, let us have a look at the steps involved to claim your Etsy store on Pinterest. But before that, it is necessary to understand what claiming is and why it is important.

Claiming your account and linking it to Pinterest gives you a lot of good features. One of the major features that this process gives you is the attribution of pins to your Etsy shop. Your profile picture and Pinterest name get attached to the pin so that people can find you and trace things to your store with ease. The most important benefit claiming provides sellers is better to control over Pinterest Analytics.

Generally, analytics are shown on the pins I save to your boards from your store, but by using the 'claiming' option, the analytics will appear on all the items pinned across Pinterest accounts and boards. This allows you to see which users are pinning your products and where they are pinning them. Similarly, it also allows you to see how these pins are performing.

Let us now check out the steps that can help you claim your account.

Before claiming, you need to have a business account on Pinterest. Otherwise, you cannot claim your Etsy store. It is impossible to do so using your personal account. It is always better to have a business account, anyway. It is necessary for promotional reasons. Similarly, it offers you much better features as compared to a personal account.

Steps:

- Log in to Pinterest using your business account.

- Click on the three dots present on the upper right corner—select Settings.

- Click on Claim.

- You will be presented with a few options. Select Claim's other accounts, followed by Etsy.

- A screen will appear asking you to grant permission to your account to be connected to your Etsy account. Click on allow Access.

That's it! You have just claimed your Etsy account, and now your Etsy and Pinterest accounts are linked together.

Analytics

Whenever you come across a pin that was curated or saved from your store, stats will be displayed at the top of the page. These stats are only visible to you. They feature the details of the past 30 days.

If you want to see more details, just click on See More Stats link. You can also change the timeframe in this section.

The information received from these stats can be used to understand which demographics are pinning your products. You can also check in what context your products are being pinned. The boards will be quite varied, but you will see some DIY-focused boards. But even DIY focused boards will help you in the long term. You may also come across some exceptional boards that will help you plan your future strategy and adjust your pins accordingly.

Claim your Etsy account as soon as possible. It is also recommended to connect your account to Instagram as well. You should promote your content as much as possible. If you do not know how to use Instagram for business, the next chapter will help you understand the basics and the intricacies of Instagram.

CHAPTER FIVE

BUILDING A FOLLOWING WITH INSTAGRAM

Setting Up a Business Profile

Instagram has a lot of monthly active users. Some experts believe that this number is as high as 1 billion users. Instagram is no longer a niche social network and is now a social media mogul. It is one of the fastest-growing, most popular platforms that you should use to promote your business. If you don't have a business account on Instagram yet, create one as soon as possible.

Instagram is a visual-based social media platform where you post images and videos. It allows you to tell visually rich and graphically stunning and inspiring stories about your brand and business. Instagram is good for cross-posting content and can really help your brand to blossom.

How to Set Up an Instagram Business Account

Before beginning your Instagram journey, it is recommended to create a Facebook business account immediately if you do not have one yet. You cannot use Instagram's business account fully if you are not on Facebook. Once you create a business page on Facebook, you can go ahead and create a business profile on Instagram.

If you already have a Facebook business page, then move on and check out the step-by-step instructions on how to create and set up a business account on Instagram.

1. Download the App

To use Instagram, you need a mobile device. So, pull out your mobile phone and go to the app store to download the application. It is available on Google Play Store and IOS App Store as well. The overall layout and design of the app are the same across platforms.

2. Create an Account Using an Email Address

It is easy to create an Instagram account using your personal Facebook profile, but if you want to keep your personal and professional life separate, it is recommended to create one using your email address. Create your Instagram account using your business email. This way, you will be able to find people, and people will be able to find you with ease.

3. Profile Basics & Choosing a Username

Next, you need to choose a good password and username. The username should ideally be the name of your brand. If the name is already taken, try to use a name that comes as close as possible to the name you want. Remember to distinguish your name in such a way that people understand that it is a brand account.

Instagram generates an account name for you directly. If you do not want this to happen, just change the name in the settings.

4. Find Facebook Friends & Contacts

Once you create your account on Instagram, it will prompt you to find people via your contacts and Facebook. Before the following people immediately, it is recommended to set up your account and make a couple of posts. So, just click skip now, you can come back to this step later. This is not a one-time offer, so you can get back to that feature again and apply it.

5. Picking the Right Profile Photo

As you are planning to run a brand account, your profile picture should obviously display your brand logo. Later you can change it something else that is associated and recognizable with your brand. As this is not your personal account, do not use your selfie as the profile picture. Do not use any other group pictures as well.

Click on 'Add a photo.' You will be presented with a few importing options. Do not import pictures from Facebook if you have connected your personal account, as it will just pull your personal account info. You can pull information from your Twitter account if it is a brand profile.

Once you upload your profile picture, save your information. This will help you log in quickly next time.

If you do not want to save your login credentials, just click on skip.

Next, you will be presented with a list of suggests accounts to follow. You can skip this step as well, especially if the suggested accounts are not relevant to your business. For instance, if you sell vegan products and your suggested accounts are of barbeque places, avoid them, and do not follow them. Once you have made your decision, just click on 'Done' int eh upper right corner of the screen.

Once again, remember this is not a one-time offer, and you can always come back to this page later.

Quick Button Tutorial

Now that you have set up the app properly, you will be presented with a screen, which is your home screen. Once you follow other people's accounts, their photos will start to show up in your feed. In this section, let us have a quick run-through of various Instagram options and buttons.

Top Buttons:

- Camera: You can share photos and videos using this button.

- DM (Paper Plane): The paper plane symbol in the top right corner of the screen is your DM or Direct Messaging service. Here you can send and receive private messages. Use it carefully.

- Bottom buttons, from left to right:

- Home (shaped like a home): Clicking on this will bring you back to the accounts that you follow.

- Search (magnifying glass): Here, you can look up new people, accounts, hashtags, places, etc.

- Camera (addition sign): Here, you can upload pics and videos.

- Heart: Here, you can check the recent comments and likes of people on your posts.

- Profile (your photo): Here, you can check your profile and what things you have posted so far. It also allows you to access the settings menu.

6. Complete your Profile

Click on the profile button on the lower right corner of your account. Here select the 'Edit Your Profile' button. Here you can complete your profile.

Fill your contact information and bio carefully. Here you can also insert a clickable URL. Everywhere else, the URLs will be unclickable. This includes URLs posted in the caption of your photos or videos and comments as well. Do not waste time posting URLs here. URLs also work in DMs. If you want to direct people to your website, put your website URL in the bio section.

Your bio needs to be short and brief. It should contain a summary of where you are located and what do you do. If you cannot come up with the perfect bio immediately, write a decent one to start off and then go back when you have better ideas and change it.

7. Now Comes the Business Part!

Click on 'Try Instagram for Business Tools.' Follow the instructions that appear on your screen step by step. This will help you complete the profile; you can then use the tools carefully.

8. Link your Business Facebook Page

In the introduction to this section, the importance of creating a Facebook page for your business was mentioned. A business Facebook page is important because it will allow you to use business tools on Instagram. Instagram was acquired by Facebook a couple of years ago, which is why a lot of integration is seen between these two services now.

9. Start Posting

It is recommended to post a couple of posts on your account before the following anyone or asking them to follow you. People will not follow your account if they see nothing. A couple of photos that represent your brand will help you significantly.

10. Write Captions and Use Hashtags

Do not write too lengthy captions. Keep them brief and pair them with appropriate hashtags. Hashtags are not just for fun; they are important tools that can help your brand grow. They allow your content to be found with ease. Use targeted and specific hashtags instead of using generic ones such as #love, #sun, etc.

Do not add too many hashtags to your post. Instagram allows 30 hashtags per post, but it is recommended to use fewer than that, or your followers will feel bombarded.

11. Follow People and Get Social!

Now that you have completed your profile and have shared a few posts, you need to start following people so that they can start following you back as well. Click on your Profile page and go to the options page by clicking on the gear on the top right corner.

Here you can find two options: Facebook friends and Contacts. Click on both of these one by one, and Instagram will open your address book. Here you can follow people one by one. Once this is done, you can start following other accounts as well. Engage with their posts by commenting and sharing. This will help you create a large audience, and people will start to follow you back as well.

The more you comment and follow others, the more they will follow you back. You can check your comments, followers, and likes by clicking on the Heart in the bottom row.

12. Find and Define your Brand's Story

Once your Instagram profile is set and is ready, it is now time to decide the purpose of the account. Some brands use their business accounts to connect with their customers, while others use it to promote their products. Some brands also use Instagram to offer sneak peeks of their products, services, and brand. Choose wisely. You can also combine all these things to create a more inclusive and proper business account. Just try to maintain the cohesiveness of the account. Else your audience will get confused.

13. Get your Name Out There

Once your account is created, link your Instagram account everywhere. Similarly, add a link to your business in your Instagram profile as well. You should add your Instagram link to your email signature. You need to drive more and more people to visit your profile.

Branding

It is true that starting your Instagram business account from scratch can be quite difficult and daunting of experience, but it is quite rewarding as well. Many times

brands start their Instagram with a lot of excitement only to stop working with dedication soon. These accounts then die out quickly, tarnishing the name of the brand. If you do not want this to happen, you need to be vigilant and dedicated.

If your account is already dead, this section has pro tips that will help you rejuvenate it. Creating a proper branding and marketing strategy is crucial if you want your business to succeed. Only dedication, patience, and hard work will help your brand grow.

Instagram branding is quite daunting, and many beginners find it really difficult because gaining attention and engagement of Instagram users, in the beginning, is a confusing and complex task. According to eMarketer, less than 50% of brands are genuinely active on the platform. The number may go up in the future, but it shows that there is much to learn about branding and marketing on Instagram.

Benefits of Increasing Instagram Branding

There around 1 billion active users on Instagram, which is why there are lots of opportunities to develop and grow your brand. More than 80% of active users check their feed at least once a day.

While you can always add paid ads on Instagram, you can also market your brand for free if you are dedicated enough.

Track Instagram Analytics

Instagram keeps on rolling out new features almost every month or so. There are many features available now that have made it a really great service for sellers and buyers alike. For instance, now, the seller can check links clicks in the platform itself. Yet, there is no way to collaborate, track, or view your Instagram metrics in one single place. But there are many third-party services and apps available that can help you do this. Using these services, you can view your total Instagram engagement with ease. You can even check how many people used your name and hashtags. These services can also help you check the hashtags trending in your industry right now.

How to Improve Branding on Instagram

1. Focus on Getting Real Followers

According to a study conducted by some Italian computer analysts, it was found that around 8% of Instagram accounts are either bots or act like bots. With this, they checked the number of defunct or inactive accounts, and it was found that around 30% of accounts do not post regularly or do not post at all. This means that the number of fake Instagrammers is going up day by day. These fake followers are bad for your business. These followers can throw a wrench in your plans of creating an engaged follower-base.

Inactive and spam-like bots can be avoided; you just need to focus on how to get real followers who are interested in your products and like to engage and interact with your brand.

Don't add followers just because you want to increase your follower count. While the quantity of followers is important, do not let the quality falter either. Instead of just increasing the number of your followers, try to increase your engagement with them and try to build a good connection with them. This can be done by posting questions that demand interaction.

Don't Deceive Your Audience

If your followers regularly share, comment, and like your posts, then you are in the right direction. But if your brand has thousands of followers who do no interact with your brand at all, then it means that your followers are fake and that you got them using some paid service. While the number of followers seems interesting in the beginning, your real audience will see through fake information. It will reduce your brand value.

Instead of risking things and paying for bot followers, you should try to build your brand steadily and gradually. Post at least one post per day and try to interact with at least 3 users every day. This will help you build your brand loyalty and awareness. It will show how you care about your followers and customers.

This is quite a demanding and time-consuming task, but it is immensely rewarding as well. Spend some time engaging your customers, and you will reap the benefits soon.

2. Place Your Emphasis on Beautiful Content

Instagram is a visual-based social media. To make your brand popular on Instagram, you need to create eye-catching and stunning content. If you use blank canvas with simple quotes, you will never get popular on the medium. You need to learn how to create engaging and attractive content. According to a study conducted by Forrester, it was found that Instagram is 10 times more engaging than Facebook. The number is even higher for Twitter, where it is 84 times more engaging.

Follow Basic Photography Tips

As said above, Instagram is a visual medium, which is why you need to concentrate on creating stunning visuals. Good visuals will help you engage more and more people. To create good visuals, you do not need to be a professional photographer with expensive gear. You can also create great visuals using your phone as well. You just need to follow some basic tips and methods of photography. In this section, let us have a look at some tips that can make your photos pop and your Instagram account popular.

Light

Photography is impossible without light. You need to set lights carefully if you want to click stunning photos. Do not invest a lot of money on lights and other such gear if you are a new brand. Instead, try to use natural light as much as possible. Avoid using overhead lights because they create unnecessary shadows. Always add light from the side, but try to use a lot of it. Bright images are more engaging because they 'pop.'

Subject

The positioning of the subject is important. Generally, your eyes look in the middle of the picture. It is necessary to put your product in the central area of the picture. Focus on your model or your product as much as possible. If your picture contains leading lines towards your central subject, then congratulation, you have created a successful image.

Imagine

Whenever you click an image, think of how it will look on Instagram. Instagram does not allow pictures of all dimensions. Check the dimensions of your image beforehand. It is recommended to use the rule of three to maintain the shape and dimensions of your image. You can divide your image into 9 equal squares to check whether your image fits or not. Nowadays, there are many apps that will let you do this with ease.

Shapes and Colors

Try to use bold, beautiful, and bright colors. Your colors should not only reflect your brand, but they should also look stunning. If you do not plan to use colors, create high contrast black and white images. These images will stand out and look stunning.

Another way to make your black and white images stand out is by using various shapes and silhouettes in your photography. These things can make huge differences and can make your images look amazing.

Editing

Photography is one part of clicking images and two parts editing. If it is impossible for you to hire professionals, use some good editing apps to edit your photos. Do not use too many filters, though. Try to keep things simple and attractive as you are trying to attract followers and not win a photography contest.

3. Post Content Your Audience Actually Likes

Good content can help you engage a lot of users. You need to make your content not only relevant but pretty as well. You need to post content that your audience will like. A lot of users like to follow various brands on social media, especially on Instagram. If you can let your brand and aesthetics shine through your posts, it will help you create a strong and honest audience who would love to buy products from you all the time. Always think of what content will your audience likes and want. Finding what

your audience likes and wants is quite easy nowadays, thanks to various insights options available.

Get More Audience Insights

The quickest and one of the best ways to get insights about what your audience likes is by asking them questions. Ask your followers frequently about what kind of content they would like to see. Most of them will surely let you know what they want. If you do not want to engage with your audience in this way, you can also use other methods. For instance, you can use social media analytics tools through which you can check the engagement of each post individually.

It is possible to get a lot of insights about your content and its performance using these tools. There are many insights tools available in the market now. Use them wisely. These tools will help you curate your content carefully. It will help you see which kind of content gets the most engagement and traction and which content is a dud.

4. Create Your Own Style

To become successful in the world of social media, you need to be creative, bold, and unique. You need to attract the audience by being as creative as possible. Only this will help you increase your visibility on Instagram. You need to create a style and an aesthetic of your own (or your brand). The style should be so unique that any

person should be able to recognize it and associate it with your brand.

To understand how styles and themes work, just check the account of any major brand. You will able to make out a unique and interesting style. Use these styles as templates to design your own.

For instance, many 'Goth' jewelry stores tend to use dark and 'Gothy' themes. All the posts and videos tend to be on the darker side, which helps to create an aesthetic look that is not only in accordance with the products but also appealing and pleasing. Users will understand what you are trying to sell immediately once they see your posts.

Another great example of this is Harley-Davidson. The world-renowned brand of motorcycles uses a lot of metal, wood, and similar earthy tones in its posts. This gives it a typical and iconic theme and aesthetics.

Taco Bell, too, has become quite popular because it is highly active on social media. Taco Bell uses vibrant and bright colors. This look helps it target young customers. While Taco Bell uses its themes and aesthetics all over the Internet, you can observe how the brand utilizes it on Instagram for inspiration.

Before you create a branding strategy for Instagram, it is recommended to check out your competitions. Check what kind of brand value they have and what themes and

aesthetics they are using. Try to utilize a style that speaks to your audience and you because originality matters a lot, especially to the young audience. Keep things simple but original.

5. Start a Hashtag Campaign

Hashtags are really important in the world of social media and especially Instagram. On Instagram, hashtags can be used to get masses speaking about your products, brand, and service. According to a survey, around 70% of the most popular hashtags on Instagram are branded.

Generally, brands use two hashtags per post. Hashtags can be quite elaborative, but they can be as simple as the name of the brand itself. Using hashtags, a company promotes its brand. Hashtags can also help you interact with your audience.

It does not matter if your follower count is low; if your hashtag becomes popular, people will get your products. This is why it is always recommended to start a hashtag campaign. There are many reasons why you should start a hashtag campaign, such as trying to make people familiar with your product, or finding new customers, etc.

Hashtags allow masses to get involved in your business and brand. It is a great way to build your brand from nothing.

6. Avoid Hard-Selling Language

While almost all the demographics use Instagram now, it is still the most popular in the 18 to 29 years age range. This age group generally does not trust brands on social media. They are hesitant to buy new things from the brands that appear on social media. According to research, around 30% of millennials in the United States of America are skeptical or scared about buying things from brands because of their selling and branding methods.

This does not mean that millennials do not like online shopping, rather millennials love to buy things online. Millennials are just off-put by the strange and over the top marketing strategies that many brands on social media tend to use. They can sense dishonesty in these ad campaigns. If your target audience is millennials, be as honest and open as possible. Do not try to full them. Do not try too hard.

As said above, use good videos, images, and content. It will help market your products to the target audience properly. Adding good captions to your posts is necessary as well. These captions are essential because they help users understand more about you. Do not ignore captions, as posts with no captions may appear insincere.

But adding captions to your posts is an art. You should never overdo it. Your caption should only include the important details, and these details should be prioritized. Instagram allows you to post captions that are 2,220 characters long, but it is recommended to be brief. No one likes to read too long of a post. Get to the point immediately and make your users read the posts, Instagram is not your blog, so don't write long-winded posts.

Pro Tip: You can increase the interest of users by using content that you know works. Just check which of your posts have been the most successful and which of them have received the most engagement. Check why they received the most engagement and try to replicate the reasons in the next post.

7. Cross-Promote Your Instagram

Many marketers use Instagram as their second or even third social media outlet. If you already have a social media channel on Facebook or any other social media site or app, you can use it to cross-promote your channel and product.

It is difficult to find ads that do not contain a Facebook link or a Twitter profile. Instagram is becoming more and more popular now because it allows content to be shared on various platforms, including Facebook and Twitter.

It is a good idea to build your marketing strategy by cross-promoting. This will help you build your brand over multiple channels, including Instagram. Some people believe that cross-promoting can be counterproductive and that it can hurt your traffic on all the channels, but in reality, cross-promoting has more pros than cons.

Cross promoting can help you drive your audience towards the funnel. You can provide your audience with a great experience that they will enjoy a lot, all thanks to cross-promoting.

Cross-promotion is great if you want to funnel customers. It is also good if you want to check out a variety of sources to spread your content.

Instagram allows only one link in its bio. So some people find it difficult to funnel their customers. This is why cross-promoting is essential on Instagram. By cross-promoting your Facebook, LinkedIn, Twitter, etc. you will be able to build a larger audience, and you will enable a chance to your customers to check out your content at their ease.

8. Showcase User-Generated Content

You should try to use content generated by users on Instagram. This is great for businesses and brands. According to a survey, it was found that more than 84% of millennials trust this kind of content and are more

likely to buy from a brand that uses these methods. It can play a crucial role in deciding the purchase of items.

Only 35% of users who use social media trust brands. Around 65% of users still feel some hesitations while approaching business. The UGC

- Contest winners

- Account takeovers

- Celebrity content

- Everyday users with your brand

- Influencer reviews

It is crucial to understand that UGC can be quite problematic because if you do not ask permission of users before using their content on your page, you may land into legal trouble.

If you plan to allow account takeovers, then you need to be cautious about them as well. They may alienate your audience if the person taking over your account is not good enough.

In the initial stages of your Instagram branding process, just try to remember why you are on Instagram and try to find as many new people as possible. Do not host any random contests with random prizes. Instead, try to

build trust and faith by engaging with people in a wholesome manner.

9. Make sure everything is Cohesive

Cohesiveness makes advertisements extremely lucrative. For instance, if you are trying to sell 'Goth jewelry' and you market it to small children or the elderly, your advertisements and products both will be inconsistent and incohesive. The same can be said about social media too.

On social media sites, like Instagram, your brand should be cohesive. So, if you use any logo or text on your videos and images, just be sure that these things follow the guidelines of your brand. Do not give away the guidelines of your brand. Make everything including fonts, colors, and overall aesthetics match with your brand

For instance, if you sell vegan products, try to incorporate a 'vegan' aesthetic in your posts. Build a theme and follow it.

In the initial days, do not hurry or rush while posting things on your feed. Take things slow and check whether your prospective posts match with your brand and theme. They should be coherent. If you post off-brand stuff right in the beginning, it can cause a problem with your future prospects. It may slow down your growth as followers may find your brand untrustworthy.

10. Test Everything

When you start using Instagram in the beginning, it is recommended to test everything out, including your content as well. For instance, in the case of the network alone, you should test things including

- Hashtags

- Bio Links

- Instagram Filters

- Post captions

- Call to actions

- Post apps (Boomerang, Hyperlapse, etc.)

- Types of content (video or images)

It is true that this may seem to be too much work in the beginning, but it will allow you to find the right balance between your content, which increases your reach and number of followers as well. Instagram changes rapidly, and so do the trends present on it. You need to update yourself from time to time if you really want to be successful on Instagram. Trying out new things will help you stay updated.

You can use various methods that can help you stay updated. There are also many third-party apps and sites that can help you enhance your followers and keep your profile updated.

11. Engage, Engage, Engage!

If you want to be successful on any social media site, you need to engage with your followers as much as possible. You cannot create a team of loyal followers if you do not engage with them. Your engagement will help your audience understand that you are not only patient but quite helpful as well.

The world is changing rapidly, and more and more people are now using social media to find a new product, new brands, and new services as well. Similarly, sellers all around the world are using different forms of social media to attract new customers and target the old ones as well. You need to make your brand ready for these updates and changes. Use the above-mentioned branding tips to keep your profile and advertisements updated.

CHAPTER SIX

EMAIL MARKETING

Setting Up an Opt-In Page

In the world of social media and rapid marketing, email marketing may seem quite odd and useless to many people, but this is false. Email marketing works really well. It is still the best way to convert users.

The process of email marketing begins even before you send your first mail. You need to get people on your email list before you start sending emails. This can be done with ease by setting up a landing page that can convince people to sign up. These land-in pages can be quite great if you know how to be convincing and coercive without appearing too brash and desperate. You need to win the trust of people if you want them to subscribe to your email. In this section, let us have a look at some tips that can help you get started.

Tips:

Who do you want?

In this step, you need to think of your target audience. You need to come up with some ideas about what kind of people do you want on your list. You need to have a clear understanding of things to make a proper list. Without a proper and clear understanding of whom you want on your list, you will not be able to form a message that will resonate with people properly. Your message should be able to not only enhance the interest of people, but it should also help you gain their trust.

Aiming the message carefully at the right person is a skill that you need to learn if you want to do email marketing successfully.

Take your time to think of everything and figure it out. If you really want to create a good list that will cover everything, you need to think a lot from the point of

view of the customer and the seller as well. Only start email marketing when you learn how to speak the language of your customer.

What do you want them to do?

Your email opt-in page should be opt-in page only. The only motive of this page should be to get people to sign up for your email list. It should not do anything else other than asking people to sign up for your email list.

Each little element and every word on the page should only focus on this action. If you add anything else to the page, the purpose of the page will be lost. So, do not add your regular links or sidebar to the page. Create a page that is only focused on one thing and ignore everything else. Your approach towards this page should be different than any other page of your store.

What are the essential elements?

Your email opt-in page needs to have these following things:

- Headline: You need to come up with an exciting headline.

- Benefits: You need to tell the benefits of your program and products in simple bullet points.

- Call to action: You need to convince people and tell them expressly to sign-up.

- Opt-in Form: You need to add a section where they can actually opt-in.

- Proof: You should add some sort of social proof. This may include testimonials, subscribers, media mentions, reviews, etc. *

* The addition of proof depends on the number of criteria. If the strength of your brand is high, then you can add it.

What incentive should you give?

The incentive is like an ethical bribe. It is given to people to convince them to do something. You can offer some incentives to your followers to get them to sign up for your email subscription.

These incentives may include audio seminars, webinars, free reports, or any other freebie. These offers should be instantly gratifying, though.

This strategy works perfectly fine in many fields, but in others, thanks to the rise of technology, not many people 'fall prey' to it. Your email directly goes to the spam folder in such cases. The best way in such cases is to focus on the incentive carefully. You can offer a 'broken down' incentive. This can include parts of video or

books, etc. People should understand that you are giving them more than what you are offering.

How long should your copy be?

Your copy should only be as long as it is necessary. Do not add random data to your copy. When designing an opt-in page, you need to have at least these three things: Benefits, Headline, and Call to action. But you can add more things by thinking of other things to add by checking what your target audience may need.

Do remember to add a reminder letting your subscribers know that you respect their privacy and that you will not share their private data.

How much information should you ask for?

The less data you ask from people, the more likely they are to sign up for your subscription service. People are more likely to subscribe to a service that only requires their email address as compared to a service that asks for their name and email ID. This shows how even something as simple as 'name' can reduce the number of your subscribers.

But do not change your format if you absolutely need some data from your subscribers. For instance, if your business requires name, phone number, and email id of your subscribers, then you must add it to your form.

Build trust, as it will help people to open up to you. This way, you will be able to communicate with people on a regular basis.

What works better?

All the above tips have been tried and tested for many years, and they work. But email listing is a subjective task that changes according to you, your business, and your target audience as well.

You need to adjust your button colors, headlines, and many other tiny tweaks. These things may increase your opt-in rate.

Ultimately you need to tweak your landing page as much as possible to make it perfect. Having a good opt-in rate is necessary, but it does not mean that you should attract people who are not relevant to your business. Your opt-in page and email marketing should be a target to only those people who will buy something from you. Remember all the steps and follow them carefully.

Setting Up An Autoresponder

What is an email autoresponder?

An email responder is a form of email marketing technique. It is automation software that sends an already written message to the contacts on your list. This sending of emails is triggered when the contacts fulfill a

condition that is predefined. There is a multitude of conditions available, including birth dates, cash purchases, etc.

There are many reasons why you should set up an email autoresponder.

- It helps you save a lot of time and effort.

- It can help you create and maintain a good relationship with your contacts.

- It nurtures leads.

Gone are the days when people thought that autoresponder is only meant for big companies. Now anyone can set up an autoresponder. There are many affordable options available on the market. Nowadays, you can also find many free options that come with limited features, use them wisely.

What is the purpose of an email autoresponder?

There are many reasons why you should use an autoresponder.

- To send important messages to your contacts even when you are not around.

- To send important messages to your contacts without having to do it manually.

- Lead people towards the funnel.

- Send custom and tailored messages to specific groups in your list.

- Create income by driving conversions and engagement.

Examples of when an autoresponder is used:

- Sending discount codes.

- Sending special offers.

- Sending welcome emails.

- Sending reactivation emails.

- Sending abandoned cart emails.

How does an email autoresponder work?

Using an autoresponder is easy. You just need to write your email and then schedule it. The message will get sent on its own. If you use the right software, you will be able to send these emails without any problem.

To send these emails properly, you just need to create a proper automation marketing workflow. You need to set up some rules that will then 'trigger' the software to send the message automatically.

Next, you need to define an entry point for your workflow. This means that you need to set up a specific situation or a condition that will trigger the workflow and set it in motion.

Next, you need to check which trigger conditions are still to be answered in the workflow. Target them and add actions for them.

Once everything is done, you just need to check the order as well as the frequency of the emails. For instance, in the case of new subscribers, you should send a 'welcome' email in the beginning, followed by other crucial emails in the next weeks.

What to Write in an Autoresponder

An autoresponder is important if you want to go out and do not want to lose business. If you plan to stay away from your office for a while, it is important for you to set up an autoresponder. It is a crucial email-marketing tactic, as well.

An autoresponder message is a notification that people receive when they try to contact a person who is out of the office or who is unavailable. These messages generally contain some sort of information that helps the person sending the email.

These messages generally include:

- How long will the person be unavailable?

- Dates and duration

- Whom should people contact when the person is unavailable

- When will the person return

The Kind of Messages You Shouldn't Send:

You should not mix personal life with professional life. Whenever you communicate with people for business purposes, you need to be professional. Never send messages like:

'I am not in town now. I am out of my mind, and I really don't want to talk to you all. Contact me later when I get back. Bye and enjoy.'

This is an inconsiderate and childish message that many people will find offensive. If you plan to send such messages, then stop immediately.

If you are confused about what kind of messages you should send to people, don't worry. Here is a short list of samples of autoresponders that will help you create a good and professional autoresponder message. Use these as blank templates. Make necessary changes wherever you want. Try to personalize these messages for added effects.

Example 1

[Your Greeting]

Thank you for your email. The store is closed for the holidays. It will reopen on (date). Meanwhile, if you need immediate assistance, please contact us on (phone number). Sorry for the inconvenience.

Best Regards,

[Your Name]

Example 2

[Your Greeting]

I will be unavailable from (date) to (date). Please contact my partner for immediate assistance.

Kind Regards,

[Your Name]

Example 3

[Your Greeting]

Thank you for your message. I will be unavailable for some time. If you require immediate help, please contact (alternate person). If you do not need immediate assistance, I will get back to you as soon as I return.

Warm Regards,

[Your Name]

Example 4

[Your Greeting]

Thank you for your email. I am not in the office currently, and I have no email access. I will be back on (Date of Return).

Meanwhile, if you need immediate assistance, please contact my phone (number).

Kind Regards,

[Your Name]

Example 5

[Your Greeting]

Thank you for your email. I am not available this week. Please contact (Contact person) in case of an emergency.

Best,

[Your Name]

Example 6

[Your Greeting]

Thank you for your message. I will not be available from (Date) To (Date). Please contact (Contact Person) for urgent matters.

Best Regards,

[Your Name]

Example 7

[Your Greeting]

Thanks for your email. Your message is important for the company. I will respond to you soon.

Thank You!

[Your Name]

Promote New Products

When you start selling a new product or a service, you are highly excited about it. You want to promote it and want people to buy it. But there is often a question in the back of the mind of a new seller as to whether or not his or her product will sell. If it does sell, then great, but if it does not, there are many tricks that can be used to sell the products.

Email marketing is a great way to sell and promote products and services in the digital world. Many researchers have come out and have proved that email

marketing really works. Learning email marketing and how to promote your products using emails is not difficult. In this section, let us have a look at how you can promote your product with emails.

Marketing automation is a great way to run your marketing campaigns online. They can help you promote your product with ease. If you plan and execute things properly, you can target your prospective audience and also deliver your message to the audience correctly.

In this section, let us have a look at how you can promote your new products using email marketing efficiently.

To begin, you need to design a promotional campaign before you start promoting your product. Your promotion campaign needs to familiarize and tease your contacts (subscribers) about your upcoming project. It should give sneak peeks to your new plans. It should give you some details about what you are about to offer in the future. This way, a sort of anticipation will be created in the mind of your subscribers.

1. Making a Good Campaign is Not Difficult

Your campaign should include:

- Create interest in the minds of people.

- Disclose information about the main features of your products.

- Create anticipation about the launch of your product.

- Motivate people about your product. They should feel interested in ordering your product.

- Ask them to provide feedback.

- If you do this properly, your loyal and honest customers will wait for your next big announcement.

It is recommended to launch your products around the time and dates when your audience is already quite engaged and active. This may include holidays, vacations, special occasions, days, etc.

2. Plan and Create Content for the New Product

If you want to launch and lead a successful promotional campaign, you need to create good content around your product. This content should be able to provide all the necessary and relevant information about your product to your customers. It should also be able to create some curiosity and anticipation about your product. You should be able to explain why it is necessary to buy your product. You should be able to show why it is useful and how it can help your customers.

You can also launch workflow with the help of emails and various other means and methods.

You need to decide what kind of content, emails, landing pages, etc. you need to incorporate in your plan. It should be created carefully. You should have a proper goal even before you start your marketing. Always ask yourself what the purpose of your marketing strategy is. The goal should always be related to the promotion of your service and product. It should always send out information about your Etsy store.

Your content should:

- Help you build a good contact list

- Reach the target audience

- Inform your contacts about the pros of your products and why they should use it.

- Inform your contacts about the various functions of your products.

- Build brand awareness and make your brand successful

- Inform people about how your product solves problems and helps them.

- Increases pre-order sales.

To prepare content, it is necessary to refer to various data available about your products and industry. You should also refer to news items and articles that will help you collect information. Use this information and incorporate it into your emails to your subscribers as well. This will help you create a good marketing strategy.

If your product is new and unique, it is necessary to promote in such a way that it should be the focus of your campaign. Do not talk about your old products unless absolutely necessary. Also, do not talk about things that you have already discussed or of things that your contact already knows.

Keep your message and emails as clear and lucid as possible. Include a call to action in each and every email. This will increase the interaction and impact of your emails.

Keep your messages relevant.

3. Present the New Product or Service From Every Angle

If your new product has a multitude of uses, you can promote it in a variety of ways possible as well. You can even create a series of emails to target and expose the variety of uses of the product.

If you want to let people know about the benefits and features of your product, just send a simple and short

message. This will make the message more memorable and comprehensible. You should direct the messages towards groups of recipients carefully.

You should display the advantages, features, and benefits of the product. To assure people that your product fulfills their expectations and needs.

4. Solicit External Reviews

External opinions and reviews can be great for your business and marketing. It enhances and improves your credibility. You should send some samples or demos of your products to people who are on the top levels in your field. Ask them to review and test your products. Opinions of these people will help your products get more popular. These opinions will help people who are on the fence and push them towards buying your products.

If you are into the cosmetic and personal care business, you can also contact bloggers and YouTubers to review your products. If you do not know how to incorporate YouTube into your business, just contact the YouTuber, he or she will help you.

5. Prepare a Special Offer for Subscribers Only

Email marketing allows you to stay in (personal) touch with your consumers. If you execute email marketing properly, you will be able to create really good and long-

lasting relationships with your customers. But remember, long-lasting relationships are built on trust only, and the trust needs to be mutual if you want the relationship to succeed.

If you create your contact list carefully, you will be able to interact with people who are really interested in your products and services. You can then give special offers to a select few of these by forming an 'elite' club.

Show your subscribers that you care about them by sending them unique offers that cannot be found anywhere else. This may include freebies, coupons, messages, products, etc. Personalized products are another great way to show people that you care.

You should contact only a chosen few about this, though. The offer needs to be exclusive. To do this, you can add caveats like 'only for the first 10 subscribers', etc. This will help you get quality subscribers in no time.

6. Diversify your Marketing

It is recommended to come up with a good and well-thought strategy before starting your email marketing chain. Along with this, it is also recommended to change your strategy from time to time and update it often. You should be able to distribute relevant information to people properly. Your marketing strategy should create a buzz about your products and brands everywhere.

Careful planning and diversified marketing strategies will help you get great and promising subscribers and, ultimately, honest customers.

CONCLUSION

Etsy is one of the best sites for small business owners who want to sell their unique and often handmade products to customers directly. It provides a multitude of options that make the whole process easy and affordable to sellers and buyers alike. While there are many stores on Etsy, not all of them can be called successful because not many stores employ marketing strategies while selling.

A seller needs to be a good marketer if he or she ever wants to own a successful business. Etsy is no different. You need to market your store and your wares if you want to be successful. If you are confused about how to market your shop, then just use the tips and tricks given in this book, and you will see the difference!

CPSIA information can be obtained
at www.ICGtesting.com
Printed in the USA
LVHW051258271120
672646LV00003B/289